SUPERNATURAL
CUMBRIA

H. C. IVISON

AMBERLEY

With Sincere Thanks To;

Friends and fellow researchers, many who are named within this book, and to all those who have been so generous in sharing their experiences and knowledge, especially:

Ian and Anita Mc Call
Irene Loudon
Denise Crellin
Liz Chapman
Bill Mac Kintyre
Joan Crellin
Janet Thompson
Christopher Ashcroft
Geoff Wilson
Mervyn Donnon
Philip Corkhill

A very special thank you to Workington Library staff.

Last but by no means least; I would wish to acknowledge and to thank, Editor Steve Johnston, and Nicole Regan of the Times and Star Newspaper, owned by Cumbrian Newspapers, in respect of permissions granted to me, regarding my referring to series by Margaret Wolstenholme, and Frank Carruthers.

First published 2010

Amberley Publishing
Cirencester Road, Chalford,
Stroud, Gloucestershire, GL6 8PE

www.amberleybooks.com

British Library Cataloguing in Publication Data.
A catalogue record for this book is available from the British Library.

ISBN 978 1 84868 909 1

Typesetting and Origination by Amberley Publishing.
Printed in Great Britain.

CONTENTS

THROUGH WAYS AND BYWAYS

SEATON

The village of Seaton, just North of the mouth of the river Derwent, sits on a high ridge, where the views can be spectacular, encompassing both coast and mountain.
A strung out village, with a good mixture of both old and new buildings, this is an old community with a long history. Some of the older parts are crisscrossed with old pathways and bridleways, and there are a number of stories telling of 'monk like' figures, especially just above the river. I have been told of sightings occurring recently, certainly within the last year.

Since the flood, Seaton is more conveniently approachable from the A596 coast road, via Siddick, North of Workington. But there are a number of cross-moor roads, from which the views are wonderful.

MORRIS GUARDS

On the high road beyond Seaton, just beyond 'The Coach and Horses' a pub who's former and much older name was 'The Weary traveller' there is an ancient through – way. This track wends its way from the moor top to the coastal village of Flimby.

In common with many such places this track and its reputation have been all but forgotten by many people, but periodically, stories and incidents surface. The place has an 'odd' atmosphere somewhere between intimidating and unease, difficult to describe. There is, or was, a ruined cottage sitting in a kind of hollow, also here and there lumps and bumps that could be, probably are, remnants of other buildings that have long since been hidden beneath soil and undergrowth.

It was a beautiful late summer evening with a long soft twilight, Pat (not her real name) had been spending the afternoon with some friends in Flimby, and, as it was still far from dark she decided to walk back to Seaton taking the opportunity to call on other friends on her way home. She enjoyed the stroll, turning back now and then as she approached the moor top to admire the Solway.

At this point in time the only stories of which Pat was aware concerning Morris Guards were the tales of bottomless mine shafts, indeed there is a story of the ruins of an ancient chapel disappearing somewhere along that part of the bank.

Keeping well to the path she was soon at her Seaton friends and commented on how much she had enjoyed her walk. Her friends reaction on hearing where she had walked, what time and alone, surprised her, and the brother of the house went on to tell her what she afterwards described as one of the most genuinely frightening stories she had ever heard.

It had been a similar kind of evening and time only a few years before, there had been six of them walking Morris Guards from coast road to Moor Top. All normal not over imaginative young men, laughing fooling about, enjoying the walk and each others company.

Suddenly, a ball of flame appeared rolling before them, as they watched, dumbstruck, it rolled up a tree, stretching itself out – then it turned into the flaming figure of a man, then, back into a flaming ball rolling once more before them. Sufficient to say, that, they took to their heels and didn't look back.

Since this experience they had avoided Morris Guards, and after hearing the tale-so has Pat.

THE TIME KEEPER

Many happenings, incidents, experiences, appear to follow generic patterns, similar incidence, experienced in similar ways. Such events are nonetheless believable for that, indeed it is possible that such events follow natural laws that we do not fully understand.

This incident is a generic classic, a very recent account related to me first hand.

It was afternoon; Bill was walking the family dog, Susie, near Camerton, a village near the river Derwent, beyond Seaton, and like Seaton, a community with a long and estblished history. It was a familiar walk that both master and dog knew well, a long straight road with high dykes and hedges. Susie was tugging at her lead a little, but that usually meant that she was bored and ready for home.

Bill became aware of a figure walking toward him, it caused him no surprise for it was a popular local walk. As they approached each other it became obvious it was, as described to me, a well dressed good looking young man, wearing a dark suit, white shirt, and sporting longish hair. This young man stopped when they were within speaking distance, asking quite simply – 'Pray could you give me the time?' Receiving Bills answer, he nodded his thanks and walked past.

Susie was far from happy, something made Bill look back; the young man had disappeared. A long straight road all in good clear sight, high dykes and hedges no gateways, driveways, no way out.

Talking about it afterwards, Bill wasn't sure at what point he first became aware of the approaching figure, and he described his dress and manner as rather old fashioned, but said he had thought little of it at the time. But had he not turned around, Bill was certain, he would have thought no more of the incident.

PHANTOM COACH

There is a road near that where Bill had his experience, a road that, I have never been able to successfully identify, this particular road is said to be the haunt of a phantom coach and horses. This equipage is said to appear solid with all the weight noise and appearance of reality even down to the sweat on the horse's flanks.

There are other places in Cumbria and other counties where stories of similar incidence are reported. As a young man my husbands Grandfather was involved in such an incident, but he would never give the exact location.

It was past dark when Grandfather and a group of friends were walking home along an estate road lined with trees, when they became aware of the sound and could feel the vibration of a coach and horses approaching at speed, they leapt for the dyke.

All that passed them was noise and a rush of energy, leaving them all severely shaken.

THE CUCKOO ARCH ROMANS

Cuckoo Arch no longer exists – it was blown up, we are told, because it caused problems to double-decker buses. There are many photographs and drawings of this fine stone arch which bridged the then, main road between Workington and Cockermouth.

Approximately the original site of the haunting as it is today.

Above: Between the lights are a few of the original stones of the arch.

Left: Cuckoo Arch, before its destruction.

Courtesty of 'Click It', Murray Road, Workington.

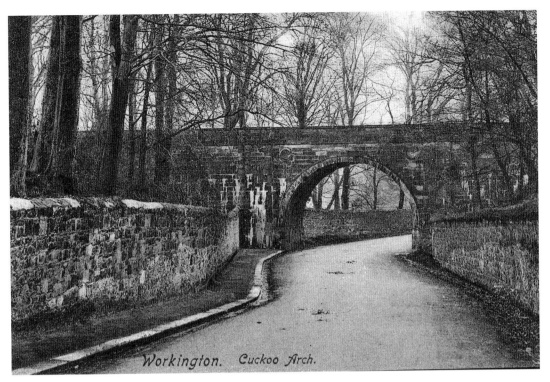

Workington. Cuckoo Arch.

Here is the original site of the hauntings.

'Click It'

This old line of the A66, though no longer a main road, is still well used. It runs up through Stainburn to-wards Clifton, and for the most part follows the line of an ancient through way. The present A66 has a new roundabout and a fine bypass to take it across the moor.

Two sections of Curwen estate were joined by Cuckoo Arch, which spanned high stone retaining walls. The road beneath it was always a sombre place, and for many years after the Arch was destroyed these high walls were left to retain the banks on either side of Stainburn Road. Part of this wall is still there, but on the right (Hall Park) side only, and somewhat diminished; the last remnants of the left were taken away when the new roundabout was built. The exact spot of the event that I am about to describe now lies under the road.

There are many, well known, and well documented stories and incidence connected with Cuckoo Arch and Stainburn Road, which do not seem to have disappeared with the arch, but thus far I have only heard of the Roman Soldiers once. It is a recent story and it was told to me not long before the new roundabout was constructed.

It was just after closing time, about 'elevenish' – after dark. A local man, which is how I must describe him, had been out for the evening and was walking home, his regular way led up Stainburn road, now this road was and still is well lit. He stopped by the arch wall on the right to light a cigarette, leaning against it as he did so: Roman soldiers began to walk through the wall beside him, cross the road and vanish into the

wall opposite. He was transfixed, not sure how many he had seen, but recalled, 'quite a number,' shaken and grateful when he reached home.

Cuckoo Arch was much too recent to have been Roman, but the path which crossed the then main road via the arch led from Schoose Farm, the name Schoose is unusual and traditionally said to mean by way/ through way or similar. A number of people believe that the name is Roman in origin. There is an ancient part tale of a headless horseman associated with Schoose, such stories are usually pure Celt, yet in a county with so much evidence of occupation – who can tell.

If you ignore the modern roads beyond Schoose, then the line taken by old side roads and pathways though now altered cut and built across, will lead you down the coast towards Moresby Roman Fort. One of the series of forts and mile fortlets that ran down the Solway coast.

That is the direction the apparitions appeared from, where could they have been heading?

Across what is now Curwen/Hall Park and Mill Field to the banks of the river Derwent. This river although now both fast and deep, was in the past, long before the banks were retained with cobbles, much wider in its bed. Stretches of the lower part, we are led to believe, were easily fordable.

Just across the Derwent, on the North side, to the right of the new cycle path lies Calva Farm, and the ruins of the Roman fort of Burrow Walls. This fort occupies what must have been a fine strategic position overlooking the river. A little farther up coast is Maryport, (Alauna) and up river inland, lies Papcastle, yet another Roman site.

Speculation? Perhaps – but fascinating: Also it is possible that the man who experienced the phenomenon stopped to light his cigarette where two ancient 'through ways' cross.

WILLIE AND THE DEVIL

The following events were told to me by my father. It is a first hand account and dates from between the wars.

I will use no names other than that in the title, nor will I name places, for the scene of these events still exists, for pre-conceived ideas can bias, and it would be fascinating if other stories came to light, and event and place matched.

There were three young brothers, all colliers making there way back after a rare night out. Money was often short, Mam was widowed and still with young children at home, but one night each shift change, it was five woodbines and a couple of pints apiece – if they weren't laid off.

It was one of those nights that anyone who knows our Cumbrian rivers and countryside will recognise, a high moon with a frosty halo the roads shinning silver

** Calva – pronounced carva, a /the hill where calves graze.

** Burrow – probably 'fortified place'.

and the river black and just beginning to spill long low fingers of milky wragg. A night fit for boggles.

The scene of the event is a little, very little, altered; the cottages are now desirable country real estate on the fringe of the Lake District. The lonnin is still there, minus its trees, and the gate? It is still there, very probably the same gate; high, sturdy, little used.

It was bitter cold, the lads rolled along hands deep in their pockets, collars turned well up whistling in an effort to keep warm. A blanket of fresh snow covered the fields but it was kicked and scruffy in the hedgerows.

Willie had won a game of two at dominos, and, as a result, had had a pint of two more than his brothers. He scuddled along some yards in front of them, whistling and laughing, his clogg corkers sending showers of sparks up from the metal road surface.

When they came to the Lonnin top the two elder lads stopped to light up, before plunging into its depths. The lonnin was cavernous, it's bottom a deep scoop worn by generations of feet, with hedgerow and trees meeting overhead, it was could be dark in daylight. By now Willie was well ahead, probably at least half way down the steep path, they could still hear him whistling and slithering, then suddenly – a howl, a cuss, a thud, then silence.

Assuming that their brother had gone headlong into the dyke, it did happen, the lads plunged into the blackness after him. Although both dark and steep the lonnin was relatively short, and soon they came through the trees back into a pool of moonlight.

They were surprised to see no sign of their brother, a scuffed track led through the snow to the cottage door which stood open, Mam's dog curled growling on the step, as they tried to touch it the dog howled and ran off – they didn't see it for two days.

Willie was on his knees in front of the fire, whimpering his face grey, Mam stood beside him, she was shaking and chalk white.

The Devil, he'd seen the Devil, it had pranced before him, then leaped the back field gate.

Whatever Willies state at the top of the lonnin, he was sober, shocked stone cold sober as he crouched before them on the on the rug. His brothers had had just enough dutch courage to go and look, for they had come the same route and seen nothing.

The cottage was the end one of three which sat where a through way, of which the lonnin was part, divided. One part wound toward the river, the other curved around and to one side of the buildings. In spite of the moonlight, the gate was just within shadow and wragg was drifting up the river path. Full of courage the two lads went to investigate.

They came back howling with laughter, a large cow with long curved horns had been gazing contentedly over the gate, staring at them with large dark eyes as river wragg wreathed around it's feet and streams of frosty breath arose from wide nostrils.

Willie was terrified, unconvinced and refused to go back outside and look. Cows can't jump gates! No one slept well, and there was a cow to catch and return, for it certainly wasn't theirs, before they went on shift.

The next morning all three went to the field, the gate, the only gate was shut and the field empty. More than that, along by the cottages, in the lane, the snow was scuffed

and tracked, bird animal, human. But in the back field there was not so much as a mark, or a footprint of any kind, human bird or animal on the virgin snow.

Until his death Willie was convinced he'd seen the Devil, his brother's just as convinced it had been a cow.

I make no comment, but a dim distant story once prevalent within the surrounding area, a story older than the cottages, sticks in mind. It's one more of those occasions when I wish that I had written down everything I have been told. This story tells of an infamous boggle.

In Cumbria boggles are usually location specific, a particular type in a particular kind of location. Sea, river, marshland etc; but I think that this particular entity was said to be a 'shape shifter'.

Also, and this I do remember clearly, and it is still spoken of. There is an infamous 'boggle corner' close by.

BOGGLES

There are some very strange, not to say odd, things in Cumbria. Not least are the entities that are described as 'boggles'. There appear to be quite a variety of descriptions, and most types appear to be 'location specific'. A boggle is usually said to be the result of murder, when the culprit has not been apprehended. But as in most things, this does not hold true for every story.

These creature's usual haunts often seem to be old throughways or byways, in some parts of the County called foot trods (or they were when I was a child), in other words natural ways and pathways that have been walked and ridden for countless generations.

Many roads still follow these traditional paths, others cross them unknowingly, and I am aware of at least one house that has been built directly over a throughway. In a county with such a long and varied history of occupation, friendly and otherwise, there must be many buildings in similar kinds of location.

Some rare creatures are said to be 'shape shifters', but most inland Boggles are usually ethereal, drifting terrifying apparitions that seem to prefer to haunt old crossroads and road/river crossings. Even if these crossings no longer exist as such, and have long since grown over or have been hidden under tarmac, the entities do not appear to desert their old haunts.

There is one well-used main road in Cumbria with an infamous 'boggle corner', and in another part of the county there is also a cross roads that still has an infamous reputation. I prefer not to name either, as I do not want to be responsible for any accidents. The older locals will know them well.

THE MOOR BOGGLE

The road referred to in this account, is neither of those mentioned above, is in character, a broad, busy, straight main road that carries regular heavy traffic. In common with many of Cumbria's roads it crosses moor land. The account is first hand relatively recent, and simple.

Three friends, all women, were driving to a nearby town. Although past dark it was just mid evening, and there was other traffic about. A formless white/grey shape crossed the road in front of them, it was quite clear in the car headlights and they all saw it.

To say that they were shaken is somewhat of an understatement.

The road that the friends were travelling on although now straight and modern, did, like so many others in the county, cover what had been an undulating ancient natural way, that had probably been used for centuries.

There are a number of road signs that made it relatively easy to pinpoint the place where they had seen the entity. On further investigation, it was discovered that somewhere beneath that particular stretch of road was the remains of an old crossroads that had also been a gallows site.

THE BLACK BOGGLE

Most of the old A66 between the coast and the village of Clifton follows the route of a path that is likely to be hundreds of years old at least. A fearsome boggle was said to haunt this pathway, at what are now the outer limits of Workington. This creature is said to be dark, shapeless and terrifying.

Perhaps it still haunts? There are a couple of post war accounts concerning people being followed through the twilight, by a gliding hovering creature that inspired a feeling of menace.

A CAUTIONARY TALE

In a book such as this, there is room for a lighter tale or two especially when they say something of our fears and folklore. There is one story from this area dating from around the 1880s, that although almost certainly apocryphal is more than worth repeating.

The road would still have been a pathway, wide enough for carts, but still no more than a track. A man was making his way home from a local hostelry where he had been accosted by an obliging female, although it was possibly a mutual, perhaps even a regular arrangement, the details are academic.

The couple had said their goodnights in a convenient barn and gone their separate ways, when the man was set upon and followed by a screaming spitting devil. He ran and stumbled through the dark in panic and desperation.

Bloody from his many stumbles and falls, his legs scratched by his attacker, the desperate man collapsed at last on his own doorstep the creature still yowling and spitting at his heels, and screamed to his wife to bring a priest.

His wife, poor woman, must have been in some fear herself. But when at last lantern in hand she came to her husbands aid and opened the door, she burst out laughing.

It appears that in the barn where the paramours had taken shelter, there had been a litter of kittens. Whilst he had been otherwise occupied one of these kittens had

attached itself firmly to the lotharios coat tales, and on his departure, the mother cat, as all good mothers would, had followed and tried to rescue her kitten.

I find it very easy to smile at this story, but part of me wonders how I would feel on a lonely dark road without the benefit of street lights, and the pathway that part of the old A66 replaced, has a reputation that it will take more than one 'cautionary tale' to dispel.

THE LAMPLUGH BOGGLE

Lamplugh is a pretty village originally dating from pre Roman times, it sits on the remains of the Cockermouth/ Egramont Roman road, and is well sign posted from the A5086. There is a lovely Church dedicated to St. Michael, but, sadly, Lamplugh Hall was demolished some time ago and all that now remains is a fine gateway bearing the arms on the Lords of Lamplugh.

The village of Lamplugh is also the home of a very unusual boggle. The Lamplugh, or Street 'yate' (gate in dialect) boggle is said to be a white horse.

Interestingly, as well as the Roman road associated with the village, there are stories of cobbles and sandstone blocks being found in the area around Streetgate, (the haunt of the boggle) this could indicate the site of a road of former importance.

THE BRANTHWAIT BOGGLE

On the high moor above the Cumbrian coast, and clearly marked from the A595, Branthwait (not to be confused with Braithwait) has an infamous boggle.

According to local legend, the boggle is a black ethereal entity that has a vaguely human shape and it appears in a dip on the stretch of road adjacent to the scout camp.

Known to generations who have used the Branthwait Scout Camp, the traditional campfire tale is that the Branthwait, or Branthwait Neuk boggle, (to use its full name) comes down the rainbow. My husband recalls, that on his first visit to this camp as a young scout, there was a double rainbow, and he admits to having an uneasy night.

Traditionally, boggles are said to derive from murder victims. The late Frank Carruthers in one of his 'Hills and Around' series for *West Cumberland Times and Star*, states that the Branthwait boggle is said to have arisen from the murder of a Romany girl who married away from her kind.

Frank quotes a classic dialect poem by Craig Gibson as his source, also commenting that an Isobella Simon, a storyteller and native of Branthwait who died in 1903, knew and told the original tale that was the basis of the story behind this dialect narrative.

A family of tinkers lived in and among a number of ruined cottages that were once part of Branthwait. Among this group there was a girl, not of tinker blood, who weary of being beaten by her husband, ran away and took refuge in the home of a villager.

The Branthwait Neuk boggle is said to be the phantom of the murdered girl in search of her head.

Here she spoke of the gypsies, telling of their raids and thieving ways, all of which proved to be true. As a result her husband and his father were taken to court in Carlisle, and her husband hung.

Some time later the headless corpse of the girl was found in one of the ruined cottages, the family had taken its revenge.

The poem concludes that, the Branthwait Neuk boggle is the phantom of the murdered girl in search of her head. A dark tale indeed, with no mention of a rainbow.

THE GREENHILLS BOGGLE

Greenhills, on the Carlisle Cockermouth stretch of the A595 has a black dog that is said to be a boggle. There are many stories of Barguest, black hounds regarded as phantoms that warn of death or disaster, and I have not found out why this particular dog is thought to be a boggle. Any story of murder connected with it probably has not survived.

Apparently, this large black hound runs along a certain stretch of the main road, appearing and disappearing from and into, nowhere. I believe that it likes to run alongside bicycles, and, in their time, horse drawn vehicles.

THE NEWTON BOGGLE

There was a particular boggle in Whitehaven, known as the Newton boggle. Its howls were thought to give warning of fatal pit disasters. On most occasions the only sign of this entities presence were its hideous howls, but when it did make an appearance, which was rare, it was said to take the shape of a large dog.

THE SALTERBECK BOGGLE

Salterbeck is a small coastal village on A597, it boasts not only a shore boggle, much reported in the nineteenth century, but also the apparition of a woman, who is reputed to be a boggle. Apparently she is seen, in daylight, on a hillside overlooking the sea and is dressed in a long dark dress and white apron.

Depending on which source you read, this entity, either frightened a vicar senseless, or rendered him dead on the spot. I suppose if the unfortunate cleric died, he could not have passed the story on.

I suppose that most old stories change a little in the telling, but it would be interesting to find something of the story behind this figures appearance, if the story it still exists.

SHAP

There were a number of stories from Shap, the old road, that seem to have become confused, and in the main have all but disappeared.

There was a generic story of a small van, which would appear in a driver's rear view mirror and stay there, lights blazing, regardless of attempts to shake it off. If a driver pulled in to allow this vehicle to overtake, it disappeared.

UNCLE AND THE COW

I always believe what people tell me in relation to experiences, our perceptions are all so different, and I believe that we can only truly speak from our own perspective, our own experience, at and in, a particular time and place.

Also, I do believe that in our modern age, we forget how dark and isolating it was, before streetlights and our constant communications. In the pitch dark with the wind howling, things can take on a very different perspective.

There is a lonnin, in a coastal town on the Solway; that had, still has, quite a 'spooky' reputation. When a young man, an Uncle by marriage was on his way to meet some friends who lived at this lonnin end, it was pitch dark and he was wasting no time.

Suddenly, there was an unearthly noise and he was thrown to the ground. Luckily, he had his wits about him, and a box of matches. On shaky investigation, it transpired that he had walked into a black cow, who, had been quite peacefully sitting in the lane. The animal had objected, quite rightly, to being disturbed.

(Anyone who has heard a cow bellow, or fox scream in the pitch dark, knows what 'unearthly' sounds like.)

Uncle was very fortunate in not being hurt, as this was a time when cows still had horns, and for a while it made an excellent drinking story, telling of the 'boggle' that wasn't!

At least I hope it was really a cow, I know the reputation of that lonnin!

THE HIGH MOORS

The high moors make up a great deal of Cumbrian landscape, and these bleak and lonely moors, are haunted, by many strange and fascinating things. There are Jack o Lantern and Will o Wisp, which may sound similar, but old lore declares that you can usually escape one but not the other, so it is best to treat them the way you would corpse lights, don't follow either.

I confess to, sometimes, being a little puzzled when differentiating between these strange manifestations of light. I believe that Jack o Lantern is usually thought of as a bright flame that skips hither and tither two or feet above the ground, this light, it is said, is dangerous to follow and will lead you to the most dangerous of marshland and bog.

Will o Wisp is a tiny intensely bright speck of light, which dances both close to the ground and many feet in the air. This is a light that confuses and misleads travellers, but not always dangerously.

In most areas, a corpse light is said to be a glowing, gliding ball that sometimes shadows funereal processions. There are many accounts of such phenomena, and it is regarded as dangerous and/or unlucky to follow such a light.

On the older roads and through ways, a number of stories persist that tell of the ghosts of highwaymen, being seen through the mist, still hanging on a crossroads gibbet. Some were apparently placed there whilst still alive, which seems unnecessarily cruel, several accounts speak of the screams of these unfortunate men still being heard echoing on the wind.

Fairies and pixies are also said to populate some parts of the moors, and most of the stories of brownies come from the high moors almost specifically around the border of what was the former county of Westmorland, or the Cumberland/Westmorland border.

Long ago everything East of Dunmail Raise was Westmorland, and this divide was hotly contested and the cause of much rivalry and blood shed, now Cumbria appears to have swallowed Westmorland whole to become one of the biggest counties in England.

BROWNIES

On the high moors, according to old lore, it was often brownies who hindered or helped the farmwife or dairymaids. According to the chronicle of *North Country Lore and Legend* (1891), there were two types of brownies. 'Some who took refuge in the dwellings of men, and became domestic drudges, serviceable but capricious.' Others were malevolent, and made their homes within the heather and hags of the high moor, and preyed on travellers. The latter type are sometimes called 'brown men', and appear in a number of cultures.

The brownies, or brown men, of the moors take great delight in waylaying travellers, and often, domestic animals, leading them away from the track ways to flounder and sometimes drown among the fetid pools and peat hags. Although they seem to take delight in pestering domestic animals, they will not harm any living thing that makes its natural home on the moors.

These small men live on berries, roots, plants and other natural food, being averse to anyone who hunts and kills the wildlife of the moor lands. Masters of camouflage, (they are the same colour as their surroundings) brownies have been known to appear before and to warn a hunter, who trespasses and kills on their land, giving him a chance to repent and leave. If this warning is ignored, then ill fortune or death will shortly follow.

Interestingly the Chronicle quotes from information whose original source could be as early as 1715, and in the subsequent story concerning brownies (although set in Durham) the text describes the same general pattern of behaviour seen across former Westmorland, and Cumbria.

It is tempting to speculate on the possibility that most of the descriptions of brownie behaviour, we accept today, came from just such early written, and even earlier, spoken sources, that were common across the 'Northern Lands' whose boundaries have fluctuated for centuries.

SCHOOLS AND CHURCHES

CROSTHWAITE

Crosthwaite Church, near Keswick, is said to have a spectre that is both armed and armoured. This ghost apparently, walks down the isle, through the altar, and disappears. Thus far I have heard of no one who has seen him recently, nor do I know of any story connected with him. But I am assured that it is an old legend.

The name means 'Cross field', and there was probably a preaching cross in the field that lies alongside the present church, there is a local legend that St. Cuthbert preached here.

This was the site of a medieval church, which could part explain the apparition in armour.

VANISHED

Kirksanton, and, Kirby Lonsdale, are not exactly at opposite ends of Cumbria, but close enough. The latter is just off the A65, well south of Kendal, the former west of Millom, south of Ravenglass.

These 'Kirks', share a curious legend. Within each, there is said to be a strange hollow in the ground, and this marks the spot where a church, complete with congregation and parson, disappeared.

These respective churches, were said to have been swallowed whole, in the midst of Sunday morning service. It is said, of both, that if you listen carefully, on certain Sabbath mornings, that the church bells ring out and the lost congregation can still be heard singing.

There are recorded instances, in parts of Cumbria, of houses disappearing into the ground. Possibly, I suppose as a result of mining. So perhaps there is some truth in the stories regarding the disappearing churches.

Also, there is a possibility of a tie with legends of a part built church being destroyed overnight by the devil. Local lore concerning Arlecdon, a village in the west of the county, is one example. The answer to the problem usually seems to involve a change of site.

Perhaps unstable ground was as much to blame as the devil.

There is no date associated with this story. The earliest version I have seen, is by Daniel Scott, Pub. 1899

THE TEACHER

There are several candidates, for the location of this account, which at first glance appears to be a generic tale. It has however been repeated to me on so many occasions, and always tied to the same geographical area, that I am convinced that there were people in my grandparents generation who remembered the original event.

It was in the time of 'penny' schools, when you were expected to pay a few coppers a day, for each child's education. In the smaller village schools, (this was a village school) the teachers were often no better off, or very little, than their pupils.

In many places it was not uncommon to give the teacher a few 'coals' or potatoes, even a scarf, a pair of hand knitted socks or mittens, in place of the pennies.

The young teacher of just such a school was killed. She was, the story goes, either thrown from a cart that had offered her a ride, or been caught by a cart as she walked to school.

The children were devastated, she had been a popular woman and much liked in the village. The pupils were given two days leave, and then told to come to the school at the usual time to see what arrangements had been made, regarding another teacher.

Two days duly passed, the children went to the school as instructed, they were soon running home in panic. For on entering the classroom, they saw the teacher who had been killed, sitting at her desk.

It is said that this young teacher was seen around the village for some time afterwards. Perhaps she was reluctant to leave her pupils, or a place she liked, and was liked.

A VILLAGE SCHOOL

This school and its village, are on the high moors, and have no connection with mining, past or present. I say this, because the 'happenings' connected with this building, have in similar cases, sometimes being blamed on 'settling', in old shafts.

The school was built, like many similar, towards the end of the nineteenth century. It is a fine stone building with a caretaker's house attached. I believe that this house is now part of the main building.

Over the years, caretaker after caretaker, have commented about the noise, and general disturbance experienced in the building. It always happens at night or in the early hours of the morning. There are distinct sounds of furniture being dragged, across the floor. In later years of lino, and then carpets, the sound was still of heavy objects being dragged, and sometimes bumped or knocked together, across a wooden floor.

No satisfactory explanation, for these disturbances, has ever been found. I refrain from naming the school in question, because it is still in use. But, there is no longer a caretaker living on the premises.

TOWNS/VILLAGES/CHURCHES

CAMERTON

At the end of the corpse road which winds it's way across the parkland and meadows of Workington Hall, stands Camerton's beautiful Church of St. Peters. It stands at a bend in the river Derwent, a bend so curvaceous that from certain perspectives the river appears to surround this ancient worship site, *c.* 800. The burial ground is surrounded, protected almost, by a wall that looks at least as old as the church, which its self dates from 1200 AD. Still used for internments, the graves there span many hundreds of years.

BLACK TOM

Inside Camerton's tiny church lies the tomb of Black Tom. Black Tom Curwen, a man of formidable prowess and reputation. Black Tom is a man of mystery and there appear to be at least four 'formidable' men who share his legends.

As you move inland the Black Tom legends become associated with treasure and a golden coffin. A much quoted and often argued candidate for black Tom is Thomas of Workington, who is said to be buried at Shap Abbey. He founded an order of 'white' cannons, quite distinct from the Augustinion order of 'black' cannons.

A Black Tom is said to have kidnapped a beautiful prospective bride. A 'Bound Bride'. Not an uncommon event within the Border Lands, these unfortunate woman were either ransomed or forced into marriage their lands and dowry taken. It is said that Tom fell in love with his captive and released her.

There are a number of references, which refer to a 'Sir Thomas Curwen' who was a warrior of note in the time of Edward 111 (1327-77). Many local stories depict Camerton Tom as a knight of 'Edward's time' and an infamous Border Reiver.

Apparently a Thomas Curwen of Camerton was accused, with others, of the murder of a certain Alexander Dykes. The accusation dates *c.* 1494/99.

Cannon, lover, reiver, knight, murderer? A man of mystery.

Whatever the truth, an effigy of Black Tom Curwen lies above a tomb in this lovely Camerton Church. A splendid figure, fully armed and replete in early sixteenth-century armour. There he lies completely black from head to toe, and, the original tip of his nose is said to be missing.

In the past his tomb lay outside the walls of the Church. The accepted local story concerning the apparent change of location features a young serving girl. It is said that she accepted a wager to visit Camerton Church yard at midnight, to see what was to be seen. She must have been a lass of some courage, for in spite of its beauty it is not a place to be after dusk. Between the sound of the river and the rustle of trees it can feel strangely still, as though time has been suspended.

It is said that she won her wager, having chipped off the nose of Black Tom to prove that she had been there. So, a church wall was knocked out, then extended and rebuilt to protect the tomb.

Black Tom walks, apparently regardless of lying in our out of this lovely church, generations claim to have seen him. Why does he walk? That is part of his mystery.

An intriguing footnote, just recently a charming bright ninety-five-year-old lady told me that when she was a child, there was a commonly held belief concerning Black Tom and Mary Queen of Scots.

The story told of Black Tom using a secret tunnel in an attempt to rescue Mary from Workington Hall, after her flight from Scotland.

GENNIE'S STORY

Gennie is not her real name. I respect and understand any request for anonymity, but here I would like to record my thanks for a clear and detailed first hand account of her experience.

It was about twenty years ago, Gennie and the family dog were taking a favourite and regular early evening walk across the fields to Camerton Church. On reaching the Church gate she let the dog off the lead as usual and the animal wandered off, as was it's habit.

Looking round Gennie saw a man whose face looked familiar, standing by one of the older local family headstones. It was not uncommon to see people visiting the graves, especially on a pleasant evening, so knowing something of the family whose grave he appeared to be interested in, she wandered across for a chat.

She described him to me as a tall pleasant looking man, well dressed in a brown suit and an open necked white shirt. It appeared that he was local, although she never found out his name, and he knew Gennie's family asking about various members especially an uncle who had died.

Throughout the conversation the dog was becoming uneasy, eventually growling and dashing off. Knowing that her dog would wait by the bank top, Gennie excused herself and followed, in no great hurry.

There is only one way out of Camerton Church yard, that is up a shallow bank and along the field edge from where you can see the full extent of the Church and it's

grounds, including the riverbank. On gaining the top Gennie turned to wave, the man was nowhere to be seen, this made her uneasy, especially as there was also no sign of her dog.

When she got home the dog was cowering and growling under the table, her mother informed her that the animal had run in, howling.

By now Gennie herself was shaking, and she told her mother of the incident. The description of the man in brown appeared to fit that of her late uncles best friend, but the age couldn't be right. Uncle had died some years before aged eighty, the man Gennie had chatted with had appeared to be no more than forty years old.

CLIFTON

Clifton in West Cumbria is a former mining village lying between Cockermouth and Workington. In common with many places of similar age and history it is divided into two parts, Little Clifton and Great Clifton, that lie on either side of a cross roads an arm of which is the old A66.

ABBOTTS WOOD

On the Great Clifton side of this division there are remnants of what is reputed to be old forest, Abbotts Wood sometimes called Monks Wood. The association is apparent.

There is however another explanation for Abbotts wood, that it was planted by a certain Richard Watts who built Clifton House (now demolished) in 1824. It is also said that he created a drive through this wood leading to the house, a drive along which people were afraid to walk. As in most cases, there is probably a great deal of truth in both versions.

I remember my father telling me of a fire at Clifton House, and also hearing of a haunted house or haunting on or near the small private estate close to the house site. But there was no detail.

I have recently come across the possibility that parts of Abbotts wood extended to the Little Clifton side of the road, onto land that has been cleared and subsequently built on. There are indeed odd remnants of what is possibly this same wood extending well towards the coast.

Abbotts Wood has many stories concerning 'shining' figures. The most persistent accounts have come from friends who lived in the village and would not go near any part of the wood at night.

I have also seen an account concerning four witnesses, it describes a shining figure with a hood, ' like a monk', this figure appeared to have no legs and floated about three feet above the ground. The apparition disappeared, going out 'like a light'.

There is a persistent tradition of monk like figures frequenting this general area, from the coast inland, especially on and around the Derwent, and as the crow flies Clifton is very close to this river.

St. Cuthbert landed at Workington on his way to Derwentwater, it is likely that he and his followers made their way up river, a faster safer way to travel. Also there was said to have been a monastery at Brigham just a few miles farther inland along the A66. Brigham and its surrounding countryside has a long history of ghostly monks frequenting the river paths.

DEARHAM

The village of Dearham lies on the outskirts of the coastal town of Maryport, the A596 will take you through Maryport via Curzon Street. A right turn at the traffic lights by the church will take you onto the A594 towards Dearham, and eventually Cockermouth.

Dearham is a village with a solid and intriguing past, that stretches well beyond that of its twelfth-century church which is said to be built of stone from the Roman fort of Alauna, modern Maryport.

There is a Roman road running from Papcastle, near Cockermouth, across the moor south of Dearham, to the coast. A stretch of this road is now under tarmac as part of the A594. This is not uncommon in Cumbria, long stretches of the A595, Cockermouth to Carlisle, take the line of a Roman road.

THE GOLDEN COFFIN

Tales of a 'golden coffin' have all the hallmarks of generic myth, such myths are so embedded in our culture, and, have lasted so long, that I believe there is a basic core of truth within most of them.

Many of the Cumbrian 'golden coffin' stories appear to hold the echo of lost royalty or of love reaching across and attempting to surmount, what in their time would have been, almost insurmountable barriers.

There are a number of traditions and tales within Cumbria concerning golden coffins. One that is now very seldom heard, is based on Whythop close to Bass Lake. This legend speaks of a great warrior laid to rest in a golden coffin full of treasure.

Closer to the coast we hear stories of a British chief interned in secret splendour at or near Ewanrigg. Apparently, in the deeds of Ewanrigg there is said to be a clause concerning the gardens, which declares, that if the golden coffin should ever be discovered there, then it belongs to the owner of the ground and not to the lessee.

At Bank End just south of Maryport we hear of a Roman officer's daughter, who pined to death after her Pictish lover was betrayed and killed, being dressed in silk and

laid to rest in a golden coffin. Ever since she has haunted the spot, even in death she continues her lonely endless vigil.

The most persistent tales with possibly the most substance come from the village of Dearham, and also concern or involve Maryport. Not contemporary Maryport, but Alauna the Roman fort that occupied the coast where the town now stands.

SEPULCHRE BRIDGE

Sepulchre Bridge crosses Sepulchre Beck on the outskirts of Dearham, this bridge is now under part of the tarmac section of the former Roman road. It is some years since I heard the story of Sepulchre Bridge, Dearham. I remember it as a frequently repeated tale when I was a child, but I have to say that it contradicts, in some part, almost every other story concerning the golden coffin that I have heard since. However, it is well worth recording.

There was a Roman officer, some say a Centurion, the more romantic a General, based in Alauna. This man fell desperately in love with a British princess, their love was denied and she was betrayed. The betrayal resulted in her death.

This princess was dressed in silk and placed in a golden coffin, before being buried with a hoard of treasure near Sepulchre Bridge. Her gravesite, and the bridge, is said to be haunted by a Roman officer carrying a lantern.

This is the princesses lover, unable to protect her in life he watches over her in death, guarding her resting place. Woe betide any who attempt to desecrate her grave in search of his beloved or her treasure.

THE OLD MILL INN

The Old Mill Inn, sits beside the road bridge that crosses Row Beck, which is situated on a bend at the bottom of Row Brow, Dearham. Over the years, the building has had many uses and varying occupants, including butcher's and undertaker's. (Not at the same time as far as I know!)

Beautifully refurbished, the mill is at present a pub, restaurant and B&B. It is also haunted, and I have the hosts, James and Alison to thank for much of the information in this story.

In the past this building seems to have been three, parts of it dating back to the seventeenth century. The haunting, however, appears to go back only twenty years or so to the discovery of a secret room.

This secret room was apparently created, the tradition goes, at sometime in the past when the buildings were made one. Probably meant as a 'priest hole', the original and only access was from the roof. It was in the course of alterations that this room was discovered, and it was said to contain, a flask of whiskey, in a wooden box and a bible. Both of which have since disappeared.

There are of course many places that have a tradition of a secret room, or rooms. How many I wonder are actually found, as this one was. Not only was this room

found to be real, but, intriguingly, the phenomena does seem to date from the time this room was opened.

A previous owner was said to have had, several exorcisms performed, not long before they left.

James and Alison state, (reference their web site) 'No one has ever felt threatened while at The Old Mill Inn'.

The Mill Inn's ghost is a lady; she has been seen, near the new hot service counter on the ground floor. She moves from here through a recently altered access that has been opened in a wall by an old chimneybreast, into the dining room. It is said that she is searching for the book that was found in the secret room. There is also the suggestion that this book was not a bible, but a diary.

There is a section of the dining room that has fairly obviously at one time been another room, if not another building. To enter, you step through what appears to have been an old doorway and step down to a different level. I was told that this part of the building always felt cold, and was associated with monks.

The Mill is an intriguing building, with a history well worth discovering.

EGRAMONT

Egramont is a market town with a charter that dates from 1267. The town now has a bypass that is accessed from the A595 coast road south of St. Bees head. Egramont Castle (like so many others) is now a spectacular ruin, it was besieged by Robert the Bruce and is associated with the famous story 'The Horn of Egramont'. This horn no longer appears to exist, but it was stated that this legendary instrument could only be sounded by a rightful Lord of Egramont Castle. There are a number of versions of a tale of the horn and sibling rivalry, one retelling by William Wordsworth.

GRAVE SIDE CAMPING

I have a friend and colleague Ian Mc Caul to thank for this truly terrifying account of the result of a childish prank.

I am led to believe that there is a Church in Egramont that is haunted by monk like figures. It is said that a priest fainted during a service on seeing an apparition pass through a wall.

It was the 1970s a group of lads were 'sleeping over' at a friend's house, something that happened regularly. One of the highlights of these nights was sitting, after dark with a candle apiece, vying each other to tell the scariest tale. Ta-ale, in Cumbrian.

Events, invented and otherwise, were being piled one on the other. It was dark and getting late, candles were beginning to gutter, when the subject of the fainting priest and haunted church came up. Now it happens that there is also a churchyard that is haunted, so egging each other on it wasn't long before they had all agreed to camp in this spot the very next night.

Come the morning, I believe that secretly most if not all of the lads, were hoping that someone else would drop out, or suggest cancellation, but bravado won.

Parent's permission was sought and a tent borrowed, without being too specific where they were thinking of spending the night. Then as dusk fell they all trouped, with some trepidation and taking care not to be seen, into the haunted churchyard.

They chose a spot, got the tent up and huddled in. It was dark and eerie with many unaccustomed noises, there were no ghost stories told on that night. It was a small tent and there was some comfort in that, so eventually, one after the other they drifted to sleep.

It was just getting light, that grey half light that seems to wipe out colour, when one of the lads, conscious of being disturbed, opened his eyes. There was a dark shadow on the tent, he thought he was dreaming, then, the shadow moved. Not only did it move, but 'it' began to pluck at and knock the tent. Then a tent peg shot out.

The lad who had woken first had no idea what kind of strangled noise he made, but the others awoke, and with screams and gollers the all shot out of the tent and as far and as fast away from the churchyard as possible. No one looked back, or if they did they were not going to say, nor have they since said, what they had seen.

In full daylight before they finally plucked up the courage to go and get the tent, it had disappeared. So they told their respective parents that some big lads had pinched it.

So ended graveside camping.

BRIGHAM

The village of Brigham lies between Workington and Cockermouth. Take the A66 and Brigham's wonderful old church with its fine Norman tower, sits to the right of the Broughton/Brigham junction approx a mile before the Carlisle/Keswick roundabout. The church stands high and is well visible from the main road, I believe that the earliest date associated with this building is *c.* 1080.

This is a church of St. Bridget, apocryphal local lore associates this site (among others) with Bride/Brighida. There is a holy well close by that was featured in a sonnet by William Wordsworth. Although I believe what is left of it, if anything, now lies somewhere on the opposite side of the A66, not a road to cross lightly, and there is a school of thought that states this well disappeared in entirety, beneath the (then new) coast to Keswick railway line.

The Derwent runs close by and it is one of the stretches of this river where monk like shapes and other forms are seen.

THE HANGMAN

There is a local story that Brigham churchyard was haunted, by a Joseph Wilson, a suicide. Mr Wilson was the hangman at Carlisle, and it is said that he threw himself into the river at Cockermouth *c.* 1757.

His ghost was finely laid in the nineteenth century, after his skull was dug up and returned to his former home.

Apparently his headstone was embellished with a hangman's rope, cut into the stone, now long since gone to souvenir hunters.

Right: Brigham Church.

Below: Scene of the hangman's grave.

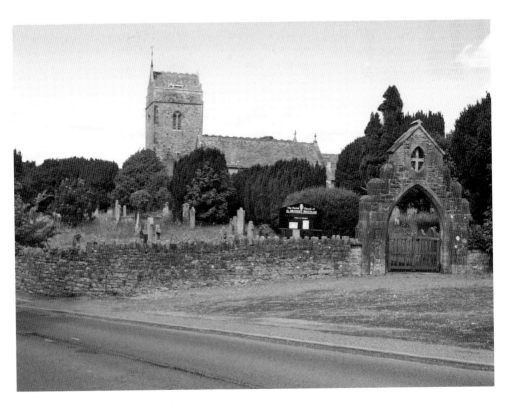

CRACKENTHORPE

Although, as a writer, I confess to being delighted at being able to legitimately include some of Westmorland's wonderful stories in a book about Cumbria, I am not at all certain how I would personally feel if my home counties name were to be superseded by another.

Appleby in Westmorland, was long regarded as the county town of Westmorland. I confess to being biased, as Appleby is one of my favourite places.

It is interesting however, that in Daniel Scott's *Bygone Cumberland and Westmorland* Pub. 1899, he describes Crackenthorpe Hall as being near Appleby, with no mention of the village bearing the Halls name. However Crackenthorpe village and Hall will be found by taking the B6542, the road to Crackenthorpe is sign posted north of Appleby.

ELIZABETH SLEDDALL

Before finding Mr. Scott's book, Elizabeth Sleddall and her story was one of those that I half knew, but in no great detail, and I confess to always associating her with Appleby. Which turns out to be part true.

Elizabeth was the daughter of Thomas Sleddall of Penrith, we are told that her portrait was found there some years ago, (this was in 1899) on a panel (we presume wood). Whether this portrait was fixed or movable, we do not know – it would be interesting to see it.

Elizabeth married a Machell, of Crackenthorpe Hall, her husband is named as Lancelot Crackenthorpe, the man who tore up Oliver Cromwell's new charter for Appleby, in open court. This suggests a date for Elizabeth, and the beginning of the subsequent haunting. For Mr. Scott seems to suggest, on some authority, that Elizabeth Sleddall became a barguest.

Our more common accepted description of barguest, is a large black dog, or dog like creature, fearsome in the extreme. Scott, quotes among others, a Mr. B. Kirkby (1899); 'One who has the power of foretelling the demise of others; or one who makes

a great din.' This then, was apparently, the definition then known and accepted in North Westmorland.

It seems, that after her death, Elizabeth visited her husband's family whenever the head of that family was about to die. Her visiting habit appears to have been engendered by some slight to herself, caused, when she was executrix of her husbands will.

It is also said, that one night of each year, Elizabeth is to be seen driving at great pace, seated in a carriage, pulled by coal black horses and accompanied by outriders, all illuminated with flaming orange lights, along the Appleby road, and that she disappears, carriage and all at a place called 'Peg Sneddle's Trough' in Machell Wood.

An account says that this happens only when the 'helm' wind is blowing, this account repeats a saying that states, 'when there are storms on the fell – Peg is angry'. In good weather, apparently the opposite applies.

There is, or was, I have been unable to find out if it still exists, an old oak, named Sleddall's Oak. A female figure, said to be Elizabeth Machell, (ne-Sleddall) has been seen to sit beneath this tree, weeping, if any ill-fortune is about to befall the Machell family or any of its members.

Here we meet one of those anomalies we find so often in traditional stories, stories I would like to add, that often have a great deal of basic truth and history at there core. Old local lore says, that Elizabeth Sleddall/Machell was taken from her grave and laid beneath a great stone near to Crackenthorpe Hall, the term of her incarceration being 999 years.

It does not appear to have taken away her ability to go a haunting.

KENDAL

Kendal, as most people will already know, is closely bypassed by the A66. For generations, a market town, it has held its charter since the tenth century. Once the largest town in Westmorland, over the centuries Kendal has experienced its share of Northern Britain's rebellions and conflicts, memories of which spill over into haunting and folklore. One incidence of this being the headless white knight, who stalks the battlements of Kendal Castle.

THE ANGEL OF KENDAL

When Bonny Prince Charlie visited Kendal during the rebellion of 1745, it is said that some of his followers raided a particular hostelry, called the Angel Inn. The inhabitants and customers had fled, well familiar with the custom of loot and destroy.

Somehow a child had been left behind, and this infant was discovered by the raiders in the parlour of the Inn. As the Scotts made to seize the child, an Angel appeared before them, protecting their prey. The raiders fled.

There is a generic similarity between this incident and the famous 'Angel of Mons' of the 1914/18 war, when an Angel was seen to guard wounded British 'Tommies'. There are a number of recorded witnesses of this event, including German soldiers.

I believe that there is still an Inn named the 'Angel' in Kendal, and that it is close to the site of the original.

A GHOST NAMED GILBERT

I have recently been told of the haunting of a building in Kendal, this building apparently backs onto an old theatre. My source worked there some years ago, when the top floor of this building, now a B&B, was mainly empty and part derelict.

Gilbert was described to me as a 'tricky' ghost. He seems to have stayed away from the pub downstairs, preferring the first floor, particularly one end of the first floor,

which staff got into the habit of calling 'Gilbert's end'.

There was a bar on this floor, I presume then unused, definite footsteps and the creaking of boards were often heard here. Look in the direction of this noise – it stopped, look away – it began again. There was also an incident in the kitchen, where bar food was prepared, when a grill pan flew across the room and smashed into a window.

Balls of light have been seen on the upper floor of the building, but only at 'Gilbert's end'.

My thanks to 'Adam' for this and other stories.

CASTLES

I have often heard it said, and by people more learned than I, that there are, or were, more castles in Cumbria, that is, northern Cumbria, than in any other part of Britain. Not all are large 'showy' edifices, but solid, workmanlike buildings, erected for practical protection and defence.

I have heard it said that you could find what is left of a castle in almost any stonewall. Somewhat of an exaggeration, but if there happens to be an abandoned building, be it castle or pele to hand, it makes sound common sense to reuse the stone. Our ancestors were confirmed recyclers before the word was invented, a glance at some of the older buildings near Hadrian's Wall will confirm this.

We tend to forget how devastating and long lasting the Border troubles were. Castles and peles must have been practically an everyday necessity in Cumbria, and an accepted part of the everyday landscape. There is a vicarage, Boltongate, which is a 'bastle house' or defendable building, there must have been others. There are many houses that incorporate pele towers, Isel Hall, Tallentire, Netherhall, Dovenby and Workington Hall, to name a few. Also church towers were sometimes built as peles, Dearham is just one example.

There are castles not only in unrecognisable ruins but some that have disappeared completely, probably more than we realise. There was a Caernarvon Castle beside the road to Sellafeild, and Crummock Water once boasted a (so far nameless) tower.

Where there are Castles there are people, it is easy to forget that surfdom continued well into Norman times. Then later, there would have been a living to be earned, by supply, repair and service. Also, the protection afforded by living in or near such a building had to be an advantage.

For good or bad all would have had influence and effect on the surrounding area, it's culture and it's folklore. Our castles and towers have given us many ghosts and many mysteries, and few things feel more mysterious than something that has disappeared yet still leaves influence, echoing of long forgotten incidence and lives.

THE SCOTTISH WIZARD

One of the most mysterious and fascinating figures to be associated with Cumbria's disappearing castles had a reputation for wizardry.

There can be few people who have not heard of Michael Scott, the learned monk that folklore, and to an extent, Sir Walter Scott, have turned into a great wizard. Michael Scott's date of birth is given as around 1180. There is evidence that he travelled widely, and his studies included mathematics and algebra. Some say that there is a possibility that he was at least partially responsible for introducing algebra to the west.

He wrote on many subjects and translated from Arabic, apparently some of his works were among Caxton's first publications. Yet folklore made him a wizard, some tales deeming him 'the wizard of the north'. Tradition has given him the ability to command imps, a local legend states that he used his imps to build west Cumbria's Boltongates All Saints Church in a night.

He is also credited to have been sufficiently skilled in alchemy to search for the philosophers stone and to attempt to create an elixir of life. He studied astronomy, which appears to have given him the reputation of being able to look into the future.

This learned man of many parts was almost certainly a monk of Holme Cultram Abbey in west Cumbria and it is broadly accepted that he died there. Also, that many, if not all, of his writings, (which would have been on parchment) were kept in store. Legend says that because of his magical reputation, the monks were afraid to examine them.

Wolsty Castle once stood about half a mile from the sea between Mawbray and Silloth, local lore tells us that it was used as a secure store for the Abbey treasures, were Scottish Wizards books and writings stored here?

We will never know, although Wolsty is on the map, the castle no longer exists. Apparently, it was lived in through various states of repair through to the sixteen hundreds, when the roof fell in. Then at the restoration it was ruinated and the stone blocks used in Carlisle's city defences, and what was left of the building has probably crumbled and dispersed with time.

In Marjorie Rowling's wonderful *The Folk Lore of the Lake District*, she comments that a writer called Satchells on visiting Burgh under Bowness saw a 'Historie' by Sir Michael in the castle there, suspended on an iron pin, and that no one dared to touch it. It is worth commenting that iron was once thought to be a protection against the devil.

In the same book Rowling records that a certain James Jackson of Holme Cultram confirmed that there was a room in Wolstey Castle called Michael Scott's chamber. Jackson's comments were recorded in 1654.

It gives pause to wonder and to speculate, what else may have disappeared with some of our Cumbrian castles?

MUNCASTER

In Jollies' *Cumberland Guide and Directory* of 1811 he describes Muncaster as follows:

> "Muncaster-House, the noble mansion and principle country residence of Lord Muncaster, a lineal descendant of the family of Pennington, who have enjoyed this estate ever since the Conquest."

The Castle of Muncaster is a splendid survivor, this wonderful building stands high and proud on its superb rocky site above the Ravenglass estuary. To see it from the A595 coastal road is a sight indeed.

This spectacular position occupied by Muncaster, is often said to have originally been a Roman site, and, Cumbria being Cumbria, it was probably something else before that. Although it appears to be an excellent defensive position, it has to be said that nothing appears on the OS map of Roman Britain. There is of course the Legionary Fortress at Ravenglass, a short distance away.

Muncaster somehow looks as though it should be haunted, and it doesn't disappoint.

THE LUCK OF MUNCASTER

Around 1464, Henry VI was in dire straits in the aftermath of the battle of Hexham. Having lost a number of powerful supporters, and apparently in some distress, he requested shelter of the then Lord of Muncaster Sir John Pennington.

The King was welcomed and given safe shelter; I believe that the room and bed in which he slept is still preserved. When King Henry took his leave, in grateful thanks for his loyalty he presented his host with a glass cup, decorated with white enamel and gold, a thing of great worth, then and now. A wish, and perhaps some would say, given Henry's devout reputation, a blessing, came with this gift. It is said that so long as the cup remained unbroken and in their keeping, the family of Muncaster would thrive.

This cup still exists, and has become regarded as one of the almost magical 'Lucks of Cumbria'.

TOM FOOL

The rather sinister portrait of Tom Skelton hangs in Muncaster, it shows a tall, rather cruel looking man in a long blue and yellow checked gown (probably his working cloths) he holds a large brimmed hat and a long staff. Curiously he holds what has always looked to me rather like a 'bleeding bowl' under his left arm, and his last will and testament is featured in the picture.

You could so easily imagine him stepping from his portrait, but as far as I know that is not one of his habits. But, the ghost of Tom Skelton, or Tom Fool, is thought to be responsible for some of the happenings within the castle, including footsteps and other unexplained noises.

He was a professional Jester and being employed by the Pennington's, he most probably would have lived in the castle. As a Jester he would have been at the beck and call of his master, to amuse and divert, and in common with most of his kind he would have been allowed certain liberties.

Skelton's sense of humour was said to be vicious and cruel, there are many things said of him, most if not all of them difficult to prove but still fascinating. It has been said that the fool in Shakespeare's *King Lear* was modelled on/ inspired by this man. Fascinating, but the dates don't fit.

It is believed that he did commit murder by beheading the local joiner, there are certainly a number of similar versions of this tale. In Dickinson's *Cumbriana*, this vicious assault is described almost as a jest.

It would appear that Tom Fool was not always pleased by the way the joiner behaved toward him, so, coming upon the man asleep with his head resting on a block of wood, Skelton took an axe and relieved the joiner of this portion of his anatomy. Commenting after he hid the unfortunate mans head among the wood shavings, 'when the joiner wakes he will have some trouble to find his head.'

Other versions of this story concerning Skelton, the joiner and his sad end, give slightly varying reasons for Skelton beheading the joiner on behalf of a rival lover of Helwise, the then daughter of the house of Pennington.

For instance, in Armistead's *Tales of The English Lakes* published in 1891, there is a somewhat 'May Day and flowery' romantic version of the tale of Helwise and her carpenter lover. A jealous friend of the carpenter betrays them to Sir Ferdinand Hoddleston of Millom, would be suitor of Helwise. In this, as in a number of other similar versions, Hoddleston bribes Tom Skelton to rid him of the carpenter.

The inescapable common theme in all these and other, versions, is Skelton beheading the carpenter. Perhaps there is some truth there?

Parts of the lower land around Muncaster is a nightmare of marsh and soft sand, in the times before well marked pathways and metalled roads, to say that some stretches were dangerous to cross is an understatement. Locals would be aware of the safe

ways and markers, but for most of these paths not to be generally known made good defensive sense. There were, and still are, places where having some knowledge of the run of the tides is essential, the Esk Estuary's infamous quick sands being an example.

One tradition describes Skelton sitting beneath a tree outside Muncaster, in the hope of waylaying travellers, strangers to the area, who were in need of direction across these dangerous areas. Local lore tells us that if Tom Fool liked or was impressed by those who enquired the way, he directed them to a safe crossing. If the opposite was the case, and the Fool was displeased, then travellers were directed to a dangerous path and Tom gained great amusement from watching them flounder, and sometimes drowning.

Why the Jester walks, no one seems to know. Perhaps his uneasy spirit still searches for his own brand of vicious mischief.

THE WHITE LADY OR THE MUNCASTER BOGGLE

This story dates from the early nineteenth century, and is so famous, or infamous that it has to be included in any mention of Muncaster.

I have been fortunate in having the local version of this story repeated to me on a number of occasions. It varies very little and seems to be widely believed, and experienced.

The white lady is said to be the ghost of Mary Bragg a young woman who lived in Ravenglass. There is occasional confusion in the telling, as to whether Mary herself was a housekeeper, or it was her rival in love who held such a position.

A Miss Littledel who held a position at Muncaster Castle, was said to be enamoured of a certain John Pike, a house steward there. Mary Bragg was also in love with John Pike, and we are left to presume, he with her.

Miss Littledel was also said to be of an extremely jealous disposition, and local folklore tells us that she hired two men, the castles coachman, Kit Gale and a carriage driver named Scot, to dispose of her rival, Mary Bragg. Together these men managed to persuade Mary that John Pike was gravely ill, and in the throws of his fever was crying out for her. They, they assured her, had been urgently dispatched to take her to his side.

On their way through Muncaster woods, Kit Gale and his accomplice killed the helpless girl. Tradition says that she met her death beneath a tree, known ever after as Mary Bragg's oak, and that her body was found some time later in the river Esk.

This tree is no longer there it became unsafe and was felled in the 1990s, but it was for many years a source of local superstition.

There is a widely-held local belief that the ghost of poor Mary haunts the spot where she met her brutal death, walking the dark and lonely road, and apparently preferring to follow lone travellers. She has become known not only as the White Lady, but also as the Muncaster Boggle. I believe that sometimes it is simply the sound of her echoing footsteps that follow anyone unwise enough to walk this haunted road alone, and after dark.

GREYSTOKE CASTLE

Many castles have, not only ghosts, but also long lost and secret passages, and Greystoke near Penrith is no exception.

HAUNTED PASSAGE

The story is that a secret passage leads from a haunted bedroom, reputed to be in the Pele Tower, in Greystoke. This passage is said to lead to an old chapel in the grounds, and that when it was bricked up a monk was incarcerated within its depths. Knockings and noises are heard coming from what is suspected to be the walled up entrance.

THE DISAPPEARING GUEST

It is said that long ago a guest of Charles Howard, the then Duke of Norfolk, after spending a good day hunting and a pleasant evening feasting in company, retired to his room in the early hours.

There was some consternation the next morning when this particular guest's room appeared to be locked, and there was some difficulty in rousing him. At last his room was broken into and a strange sight met the servants' eyes.

The bed had been slept in, clothes and belongings were spread in their accustomed places, but of the room's occupant there was no sign. An intensive search yielded nothing. The guest was never found, and his disappearance remains a mystery.

Local legend says, however, that his ghost makes an annual appearance at the site of his last known night on earth. Also, the castle's secret passage is said to have its entrance in the room where he slept.

Apparently, anyone who has slept in this room since this mysterious event have been disturbed, even those who have been unaware of its history.

There is a fascinating and slightly different version of this story in Margaret Wolstenholme's 'Ghosts of Cumbria' 1976 series for *Evening News and Star*. Here

she tells the story of the Pele Tower bedroom, saying that the 'mysterious guest' was thought to be the devil.

Apparently the Duke had been hunting alone on the Sabbath, as was his habit, when, he was joined by a mysterious gentleman on a black horse. After a fine day's sport the Duke invited his companion back to the castle to taste his hospitality. The next morning, both the guest, and his magnificent horse, which had been securely locked in the stables, had vanished.

Ever since this event, the devil had visited the Pele Tower bedroom on a particular night each February.

Some years ago two little girls had been put in this room to sleep, and after a disturbed night they were asked to draw what had visited them, we are told that the creature in their drawing had horns and a tail.

SIZERGH CASTLE

Close to the A591 just south of Kendal, Sizergh has been the home of the Strickland family, for more than twenty generations. The Castle is said to have a locked/lost room, there are many generic tales in Northern folklore concerning such rooms and there is probably a core of truth in most of them.

Most such stories concern priests, or kidnapped brides, not an uncommon thing in the North where many women carried birth and land right.

Sizergh's story concerns neither, priest or kidnap, the legend that has engendered one of this lovely buildings many stories, tells of a tragedy that was born of love's mistrust.

THE LOCKED ROOM

Long ago, one of the Lords of Sizergh, had a wife whom he loved deeply and passionately. Unfortunately, his jealousy appeared to be as passionate as his love, and when he was called away to serve his king, he locked his wife in her room forbidding his servants to release her.

The Castle servants were so afraid of their master; to disobey him would have meant death. That in spite of the desperate woman's cries and pleas, they chose to ignore her completely. This tragic lady of the castle starved to death, it is said that the locked room was never opened, and that her ghost can still be heard desperately screaming for release.

CURSES

We hear of curses being chanted, cast or rhymed. The Romans noted curses down, and threw them into running water. Other societies burnt or hid written curses. I suppose that deep down, most of us have a degree of superstition concerning such things, and whether or not curses can, or do work?

It is now pretty well accepted that there is probably some psychological element at work in curses or 'ill wishing'.

Here are three accounts, one of a castle, one of a great house, and one about a witch, and three famous curses, that were reputed, with some evidence, to be fulfilled.

NAWORTH

The original home and stronghold of the Lords of Dacre, was Dacre itself, but in the sixteenth century Naworth was their principal home. Naworth Castle lies between Brampton and Carlisle, and is clearly sign posted from the A69 east of the city.

An informative version of the curse of Naworth, and the curse itself, has also been described by Margaret Wolstenholme, in 1976.

A previous Lord Dacre of Naworth courted a local girl of some beauty. This girl was totally unaware of her sweetheart's true identity. In time she became pregnant, and it was only then that she was told who her lover really was. Not only that, she was informed that his Lordship was already promised in marriage to a woman of his own station in life.

This wedding took place shortly after the child, a son, was born. On her lover's wedding day, the distraught, deserted girl, threw herself into a stream near the castle. Strolling the grounds with his new bride it was Lord Dacre who discovered the girl's body.

Coming upon the scene of her daughter's tragic death, standing over her body, the wronged girl's mother screamed a curse at his Lordship.

'Oh, cursed be the cruel hand
That wrought this hour to me!

May evil grim aye follow him
Until the day he die.'

Whether or not the curse was strengthened by having her daughter's body lying at her feet, as she uttered these words, who can tell.

This curse can be said to have come true, as the Lord Dacre in question died young. A mere three years after the death of his father, the Lord's young and only son died after falling from a rocking horse. Thus the Dacre male line died out, the inheritance passing to Elizabeth Dacre.

Ever after the grounds of the Naworth Castle have been said to be haunted by a beautiful white lady who stands by the banks of the stream.

LEVENS HALL

Levens Hall is to be found from the A590, just south of Oxenholme, near Kendal. The house and grounds have been open to the public for some years, and chief among its attractions are Levens' world famous gardens.

As well as other apparitions and spectres, this lovely house has a gypsy ghost, and also, a famous and well documented, gypsy's curse.

Levens' small black dog is, by all accounts, a friendly little ghost, who seems to love nothing better than running upstairs and darting around the legs of guests. Also often seen in the main hall of the house is a pink lady, complete with mobcap and printed dress. This lady is very unusual, there are many known, grey, black, and white apparitions, and there is a castle in Scotland with a red female spectre, but pink is truly out of the ordinary, and quite fascinating.

The gypsy ghost is known as the Grey Lady of Levens, and she appears regularly. One of her haunts is said to be the bridge over the river Kent. The story behind this haunting has a touch of melodrama, as it is said that the gypsy came starving and begging, to the door of Levens, and was turned away empty handed.

For this she cursed Levens, declaring that no man should inherit until a white fawn was born to the deer in the Levens Park, and the river Kent should cease to flow. Shortly after she was cast away, (some versions say the morning after) the gypsy woman was found dead. She had either starved or was frozen to death, the descriptions vary slightly. If it was winter when she was cast out, possibly a combination of both?

The story's date has usually been accepted as eighteenth century. Strange but true, for generations, inheritance passed down the female line, it being 1896 before a male heir was born to the family. In that year, a white fawn was born in Levens Park, and the river Kent froze.

An interesting footnote, in the Guide Book to Levens Hall, written by Susan Baggot, it says that when Lisa Baggot was just seven years old, she saw the gypsy, and that this apparition apparently walked through a building. The (then) little girl went on to describe the figure's apparel, and it was an accurate description of gypsy dress of the early eighteenth century.

THE WITCH OF TEBAY

Anyone who has driven the M6 over Shap will know Tebay. Mary Baynes of the old village of Tebay died age ninety, in 1811. Mary was one of the most famous, or perhaps, infamous of the northern witches. She is credited with at least one accurate prophesy. There are a number of contemporary accounts telling of her prediction to the pupils of Tebay school, informing them that someday horseless carriages would run over Loupsfell. The railway now runs across a portion of the land to which she referred.

One day Mary's cat fell foul of a mastiff owned by the landlord of the Cross Keys Inn who worried it to death. Mary insisted that her pet should be given a decent burial, and a man named Willan was given the task.

The grave was dug, and Mary handed Willan a book indicating a part that she wished him to read. The man was having none of this, and picking up Mary's cat by the leg, flung it unceremoniously into the grave, with the now infamous words:

'Ashes to ashes, dust to dust,
Here's a hole, and in thou must.'

Not unnaturally Mary Banes flew into a rage, and trounced him squarely, with a warning.

A short time later, Willan was ploughing and the handle of the implement whipped up, seemingly of its own accord, striking the unfortunate man in one eye, and blinding him. Of course Mary was blamed for cursing him, and bewitching the plough.

MOST HAUNTED

WORKINGTON

The A66 Trunk road ends, or begins, depending on your point of view, in Workington.

Lying on the West Cumbria coast between Maryport and Whitehaven, Workington was world famous for its, now sadly redundant, Iron and Steel industry that exported rails worldwide.

The town also boasts a historic past, St. Cuthbert and Mary Queen of Scots being two of the famous figures to have landed here. It was at Workington that Mary first set foot on English soil, and from Workington Hall that she was taken into protective custody by Lord Lowther.

The town is also distinguished not only by being one of the most haunted places in Cumbria, but also by having an excellent and growing written record of such events. This is thanks to a group of the local Civic Trust members.

The stories printed here, represent only a small proportion of those now researched and listed.

THE HIPPODROME GHOST

This story was told to me by the late Reg McCallum, who was a cinema and theatre researcher and historian, he also worked for many years as a cinema projectionist.

The Hippodrome cinema is now mostly demolished. I say mostly, because the buildings that formed the theatre front and box office are still standing, but have now returned to their former use, as private homes.

It is a building that many people will remember. The front and body of the cinema was constructed across and through several three-storey houses on Falcon Place, whose preferred local and much older name is Hagg Hill. The back of the building was literally a house in South Watts street directly behind.

The cinema itself consisted of a single storey with a steep rake, which was entered by a sloping corridor.

A complicated building with deep foundations, it also had a subterranean ballroom which at times doubled as a rifle range. On one infamous occasion a customer was shot by a stray bullet, which came up through the floor of the auditorium during a performance. Local informed gossip says that it was a leg wound and not serious. Apocryphal gossip says that a cowboy film was showing at the time of the incident.

The projection box itself was situated in the house that backed onto the cinema and was usually entered from the street behind. The projectionist, projectors, and other equipment were all at the top floor of this three-storey building. As you entered the door of this house you were faced with a steep flight of uncarpeted stairs, which led to a small landing with rooms on either side, then there were a few more steps to the projection room itself.

It was local common knowledge that this house was haunted and that this haunting had something to do with a fire. The basic story has little detail but seems to involve a woman being trapped when the building was thought to be empty. Whether it was within the time the buildings were being used as a cinema, or earlier, no one appears to know. The houses all date from around 1880, and there are photographs of children outside the cinema in what looks like the early 1900s.

The haunting usually consisted of sound and smell, there were times when it was possible to smell perfume drifting up the projection house stairs, and on occasion to hear footsteps. Reg's account is the only one that I am personally aware of in which something was seen.

The door of the projection house was usually kept locked, especially after dark, mainly to prevent children entering. Apparently they would shout, run, or sometimes throw things up the stairs.

Reg was in the projection box working alone when he heard footsteps on the stairs. At first he took no notice because he was aware that there was another projectionist in the cinema, and so presumed that he had come round. However the footsteps stopped on the landing, then could be heard crossing one of the unused first floor rooms.

Opening the projection box door, Reg realised that, although it was past dark, the staircase light was not on. He remedied this and calling out went down to the landing, all the first floor rooms were empty, he then ran downstairs to check the front door, it was still securely snecked.

Although far from happy, he had to go back to the projectors for he had a film running, however, he left the stair light on and the box door open. All was well for a while, then Reg heard footsteps – this time going down the stairs. He ran to the door of the box in time to see the top of a woman's head as she descended the main stairs.

When he got to the landing, which was only a step or two, both she and the sound had gone. There was no sound of a door being opened or closed, and on examination it was as before – snecked.

As he told me later, all he saw or remembered of the unexplained figure was the top and back of a blond head. But to say that he was shaken was an understatement.

The haunted house on South Watts Street, is now completely demolished as are its near neighbours.

VAMPYRE

Like most people in Cumbria I have heard of the Croglin Vampire; it is an almost unique story within the area. This tale revolves around two brothers and a sister who became the tenants of Croglin Grange in the Vale of Eden.

The girl, whose name was Amelia, was attacked twice whilst staying at the grange, on both occasions the monster breaking into her ground floor bedroom by means of the window.

After the first attack, her brothers took Amelia to Switzerland to recover, before returning once more to Croglin.

Some months later the girl was again awakened by noisy attempts to break through her bedroom shutters. Her screams awoke her brothers who, this time, were well prepared. Edward, her elder brother, rushed outside just in time to take a shot at a sinister shape, as it was attempting to flee.

This figure stumbled and began to limp, and on seeing this, Edward followed it until he saw the creature entering Croglin churchyard. Both brothers returned the next day with a company of men, and on searching, found an open family vault and within it, one intact coffin.

When this coffin was opened it was found to contain a well-preserved body that appeared to be not only comatose, not dead, but also had a leg wound. Without further ado, the creature was removed and burnt, there and then, in the churchyard.

THE VAMPYRE OF WORKINGTON

Croglin was the only vampire story that I had found in Cumbria, until, courtesy of our *West Cumberland Times and Star* I came across the Workington incidents. The story is dated to the mid 1700s.

It began with two local men, who, hearing terrified screams investigated a nearby local farmhouse and found a girl being attacked by a creature with blood-dripping fangs. On being interrupted, the creature fled in the direction of Seaton, a village on the north side of the river Derwent.

The rescuers, almost as shocked as the victim, took her to a tavern where they dressed her wounds and tried to calm her down. In spite of her truly terrifying description, there were one or two that suggested that the attack might have been carried out by an over-passionate suitor. This suggestion was quickly dismissed however by James Warren, a blacksmith whose wife had been attacked in similar fashion.

By now a crowd had gathered and the angry mob soon headed for Seaton, following the trail to an old cemetery. They discovered that some of the graves there had been disturbed and their contents scattered. However, there was one untouched coffin. When this intact coffin was moved, dreadful sounds issued from it, so they removed the lid and discovered the creature.

Showing great courage they dragged the vampire from its resting place, nailed the creature to a tree and burned it.

So perished the vampire of Workington. But, they say, that the very nail, which was used to pin the vampire, is still in the tree, and to remove it, is to die a fiery death.

TOYS

There have been a number of recorded incidences that appear to involve or to suggest the presence of children, within a relatively small area at the 'high' or 'old town' end of Workington.

The A66 enters the town via Hall Brow, one of the gateways that lead into Workington Hall grounds is set back to the right just at the point where this hill begins its descent into the town centre.

This particular gateway has been moved from its original position and re-built, to allow access to a car park that is set within part of the hall grounds. This area has had many differing uses spanning what must be hundreds of years, and all obvious signs of any buildings, walls or other pathways have long since disappeared.

In the area between the main road and the newly positioned gate, children's toys, described as 'old fashioned' toys, have been seen. On most occasions the toys have been a rocking horse and skittles, but one sighting specifically mentioned a clown-like doll, and described it as 'floating in the air'. The sound of children's laughter has also been heard.

These phenomena have been experienced, behind and to the right of what was the original position of the gateway. Old photographs exist showing the estate walls and a stone built lodge to the left, or downhill side of the old gate.

Here is the location of the apparitions.

Children's toys have been found near this gateway.

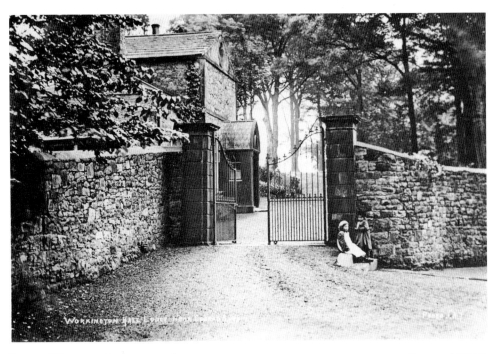

Scene of the apparitions past and present.

Courtesy of 'Click It'

THE RHYMING CHILDREN

Directly opposite this entrance to the hall grounds, on the left hand corner of the A66 Park End Road 'T' junction is the Helena Thompson Museum, a fine Georgian house that was bequeathed to the town for its present use.

In the mid nineties a friend was on holiday relief at the Helena Thompson, a job she fulfilled regularly at this and other museums in the area. The museum building is 'L' shaped consisting of the main house and what was the stable buildings, now part of the museum.

Within the right angle formed where the stable block joins the main house is a small car park covered in shillies, the main car park and gardens being at the rear.

It was a cold mid November day and Irene was on duty alone, but it had been quiet, so between regular rounds she settled down to some work in the office in the main building. She said that she had been vaguely disturbed on and off by noises, but had not taken much notice until they became quite loud and she realised that it sounded like children playing.

So she headed through the museum towards the front car park that seemed to be the source of the disturbance. The sounds became louder as she approached them, and she was aware of children's laughter. Irene pushed open the side door directly into the parking area, nothing, and the sound had stopped. She checked the back garden and car park, and checked the museum, but all were empty and quiet. Then realisation

The grounds of Workington Hall.

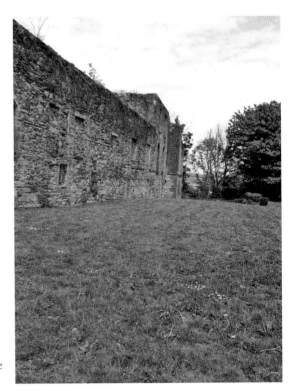

Some of a number of sites where the phenomenon have been experienced.

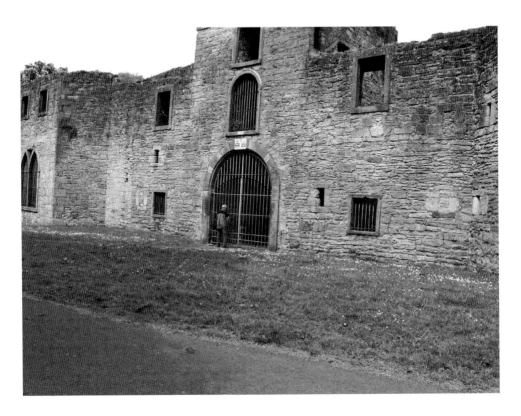

Visit the Hall today and you might hear The Rhyming Children yourself!

came. It was 2 o'clock in the afternoon, on a school day, so where had the children come from? The front car park was covered in shillies, you could not so much as tip toe without disturbing them and Irene hadn't heard any such sound.

Then came the thought that shook her; in the back of her mind Irene had recognised the rhythms of the children's voices. They had been rhyming, nursery rhymes, and being a relief warden of the close by Workington Hall, she was well aware of the local stories of The Rhyming Children.

The Rhyming Children are heard, and have been seen, in the courtyard and grounds of Workington Hall. All reports there have been of the sounds have been similar, and specifically state that the children sound happy; laughing and playing. Irene commented that the children that she had heard sounded happy.

Another constant is the rhyming, the rhythm and rhyme of nursery rhymes. But no specific words or particular rhyme are discernable; it's really intriguing.

There is one part of the known history of the hall that has been suggested may tie with children. During the Border troubles a family named Graham; men, women and children, were captured and incarcerated by the Curwens, in the dungeons of Workington Hall. The prisoners were eventually released and deported, but as in many such cases, fewer came out than went in.

It has been suggested that the children may have been let out to play on occasion, and that it is the ghosts of those that did not survive that are heard in their last happy hours. This is held to be a Victorian suggestion, and I mean no disrespect when I say

that the Victorians did habitually give folklore and history a romantic twist.

Such a suggestion does not fit the social history of those times, the Border raids and troubles were one of the most vicious periods of British history, which gave us the word bereaved, and its meaning.

Local tradition does tell of a mulberry tree within the hall grounds around which children were said to chant rhymes. Apparently, if you circle this tree and then knock three times on its trunk Bloody Mary will appear.

It was Mary Queen of Scots and not her cousin Bloody Mary who was associated with Workington Hall. But, this story does have echoes of rhyming and spells – tenuous perhaps, yet there.

Whatever the cause of the children and their rhymes, I'm glad that they sound happy.

THE SCOTTISH WIDOW

Where the A595, the main coastal road south, crosses the Lilley Hall roundabout above Workington there is a long stretch of industrial estates. Some are relatively new developments, but a number have been rebuilt, reconfigured and changed hands over the years.

This whole area and beyond is part of Winscales Moor, crisscrossed, under the surface, with half-forgotten overgrown roads, pathways and remnants of walls and buildings. Part of this area close to the roundabout was once called Blackwood, indeed there was a wood here and there is a Blackwood Road on one of the new estates. Apart from this the name no longer exists. There is an area marked School Wood on the OS maps, which also probably speaks of something long gone and forgotten.

There are a number of stories and events that have been connected with this area over the years, whether they have or have not transferred to the buildings is a question I (frustratingly) can't answer.

There is one gentleman who, some years ago, worked in what was the old County Motors building that stood on Winscales Moor, and he told me of his experiences there.

This gentleman worked at night, and on two occasions he saw a dark figure glide across the show room. He described her as the Scottish Widow, because she looked like the lady in the adverts for the insurance company of that name. She was perfectly clear, wearing a long dark hooded cloak, and was invisible from the knees down.

It was about 2 am on both occasions that he saw her, although he had been in the same showroom at similar times without seeing the widow, and he described the atmosphere as icy.

THE BLACK SHADOW

There are two tales of the Black Shadow in Workington that may or may not be connected. This particular version probably has the least information, but, paradoxically, she was the most frequently seen of the two spectres.

This story dates from the early twentieth century, when the woman was regularly seen around the porch and steps of one of the town's churches. She was said to wait here, sometimes in vain, for a man. (Nothing is known of him, and there is speculation about his married status).

Early one morning, the woman was found dead, possibly murdered, and there are a number of suggestions as to how she met her death.

Ever since, this woman has or was seen on and around the church steps, all in black, in which she was fond of dressing. She was said to appear and disappear like a shadow. There are stories of policemen trying to move her on, and getting the fright of their lives.

I used the phrase 'was seen' deliberately, for this church and its steps are now under a large store in our recently rebuilt town centre. I have not heard of any incident within this shop – yet.

CARLISLE

Carlisle, the capital of Cumbria, is a true border city, and this superb defensive site has been occupied since pre-Roman times.

Within its known history, Carlisle, has been occupied by the Romans and burnt by the Scots. Refortified by the Romans, it was again destroyed after their departure. The King of Northumbria re-built the city in the seventh century, in the ninth it was pillaged by the Danes, and left in a semi-ruined state until 1092 when William Rufus garrisoned the castle.

This city continued to be frequently harassed, and at times part burned by the Scots. In May 1568 Mary Queen of Scots was brought to the castle in 'protective custody'.

Royalist in the Civil War, the city eventually surrendered to Cromwell. During the second Jacobite rising of 1745 Carlisle submitted to the Scots and saw Bonnie Prince Charlie, (Prince James Edward) proclaimed King of England.

Adding to this, a number of researchers and historians have a number of extremely persuasive arguments that appear to place King Arthur's court in Carlisle, although Birdoswald at Gilsland does also have a reasonable claim to be Camelot.

With such a history, it would be surprising if Carlisle, this city of the Borderlands, were not haunted.

CARLISLE CITY

In common with many towns and cities which have been occupied for centuries, Carlisle has been built and rebuilt with succeeding foundations one on top of the other. There must be times when there is and has been little clue as to what may be found when new building work commences.

When I was a child I was told a tale of holy wells being hidden and forgotten beneath the city centre. Being a child I quickly translated 'holy' into 'magic' then spent some time part frightened that I would fall through the street and into one of these 'mystical' water sources, and wanting to find one and make a wish – from a safe and dry distance of course.

Carlisle now boasts a wide and gracious main street and local stories tell us that when some of the present modern shops were being built, the buried remains of monks were discovered.

Among the modern shops, I refrain from saying exactly which one, that were once fine town houses although little of the original can now remain, there is a haunted first floor.

An elegant man in seventeenth-century costume, is said to stroll around what was once his fine drawing room and gaze from the windows.

CARLISLE CASTLE

A smiling Cavalier, is only one of a number of spectres, said to walk the walls of this fine Border fortress.

Carlisle Castle, in common with most sites were people have lived and endured in good times and bad, has an atmosphere all it's own. This fortress has seen many prisoners in the course of its long history, but few can have been as illustrious or controversial as Mary Stuart Queen of Scots.

Mary first set foot on English soil at Workington where she spent her last night of freedom. Escorted, in protective custody, by Lord Lowther, she was taken first to Cockermouth and then on to Carlisle.

Being taken back towards, and lodged in sight of, a country that she had come through so much peril to escape from, the young Queen's thoughts can hardly be imagined. It is sometimes said that she haunts Carlisle Castle, any feelings of apprehension or regret she may have experienced whilst there, and perhaps gazing out towards the Borderlands, can surely be understood.

THE CAPTAIN'S TOWER

The captain's tower is haunted by a white lady, and it would seem that this sad ghost has only been seen since the nineteenth century. The accepted story is that a captain of the castle had a mistress and when she became pregnant, it is alleged that she was bricked up within a chamber wall in an effort to prevent scandal. Since then it would appear that the wronged lady has haunted the tower in an effort to make her sad plight known.

Once again I have the writing of Margaret Wolstenholme to thank for more detail in what may or may not be the same story. She tells of a woman's body that was found during alterations at the castle between 1825-1835, this body was apparently not identified. This unfortunate woman appeared to have been 'walled in', but whether alive or dead at the time of her incarceration, the science at the time of her discovery would not have had the procedures to ascertain.

The body, we are told, was dressed in tartan silk, its feet resting on a tartan silk square, and the fingers still wore precious rings. I have previously heard other tales

of a 'body' been found, but never before have I personally come across any details concerning clothing, or any date connected with the find. It would be wonderful to know the style of dress, as this could be an accurate pointer to a possible date of her internment.

Some local stories say that Mary Queen of Scots walks the walls of Carlisle Castle, some say that it is an unknown woman, but all agree that this castle ghost is female. Most tales agree that the captain's lady is the White Lady of the Tower. Was the body found clothed in silk that of the captain's lady? Or, is the 'silken' lady the unknown ghost? Perhaps they are one and the same, and the victim of a tragic story we may never know in its entirety.

There is however a fascinating footnote. A friend recently pointed out to me, an old tradition concerning Scots who die, and are buried away from their native land. It was, and possibly still is, custom to rest the feet of the deceased on plaid, in other words, 'resting' on their native land.

So, perhaps the lady found in the early 1800s, was in fact Scottish, not merely in fashion.

THE SENTRY

There is an enduring story of the Castle, concerning one of the sentries who served there in the nineteenth century. This soldier was on night patrol when he speared an intruder who had refused his command to halt (perhaps an overactive response?) apparently his bayonet went straight through the approaching figure.

The apparition continued on its way unhindered, then vanished, leaving the sentry, not unsurprisingly, in a state of shock. Sadly, the sentry did not recover from the state of collapse in which he was found, and he died within a few hours.

CARLISLE CATHEDRAL

There are many, many stories of Carlisle's wonderful cathedral, one of the most intriguing, though possibly completely apocryphal, is that of the walking Bishop. Apparently there was occasion to move one of the fine stone effigies (we are not told which or when). The bishop whose monument it was, had on several occasions, apparently been seen to rise from his new position, walk back to his former place, and vanish.

The effigy was returned to its original position.

It is said that a tunnel once connected the cathedral with Friar's Tavern in Devonshire Street, which is said to be haunted. Details as to by what, or how, are scarce.

WIGTON

A well known, and established market town South of Carlisle, Wigton was once the home of an established weaving industry. The town sits between two main roads, A596 and A595, and is approachable from either, via the B5302.

Wigton is regarded as one of the most haunted towns in Cumbria, it is true that during a number of years of research, I have come across only a half dozen or so stories actually recorded. Also, I confess to being disappointed at first reading T. W. Carrick's *History of Wigton* published 1949, to find that he only mentioned one haunted house, 'Burnfoot'.

> 'This is one of the few houses in Wigton reputed to be haunted, but I have yet to hear a definite description of the "ghost".'

Not good news for a researcher. However: J. A. Brooks in his *Ghosts and Legends of The Lake District*, not only has these well known recorded stories, but a tempting list of others.

Brooks' list is fascinating; The Church Street Phantom, The Clinic Ghost, The Burnfoot Spirit, (possibly mentioned in Carrick's book?), The Water Street Boggle, The New Street Headless Horror.

Brooks doesn't mention the 'King's House', all I have heard is a suggestion that it is haunted, but no specifics.

There is always the possibility that these other listed stories have never been written down, such a thing must have happened, sadly, with scores of others from around the county. However, myself, and I am sure other writers, live in hope. So far I'm afraid that I have had little luck.

TIME SLIP?

It is some time since I was told this story, which is quite unlike any other that I have come across in Cumbria. I do confess to having first heard it over a glass of wine.

I have never had a secure date for the 'happening' described here, and was delighted to see that Tony Walker, who also has this story, in his *Ghostly Guide to The Lake District*, quotes 1997.

Two men were sitting in 'The Victoria', having a chat and a drink. I was told that it was quiet, late in the evening. Without warning, the corner room where they were sitting disappeared, and they found themselves looking out onto the street.

There were people walking by, and a group standing chatting, the figures were wearing clothes of a hundred years or so previously. The witnesses apparently mentioned 'leg of mutton' sleeves, which were in fashion around the turn of the century. There was also a comment that some of the figures could have been 'show people'. Both men were in entire agreement as to what they had witnessed.

I have heard different comments in relation to the length of time the experience lasted, but it seems to have been measured in seconds, and time had felt odd.

The part of the building where this event took place had been substantially altered when the 'Joiners Arms' became 'The Victoria', in 1897. The men's experience seems to have occurred in 1997.

Carrick mentions that an 'Inn' called 'The Leg of Mutton' became the 'The Joiners Arms', then in 1897, after 'extensive alterations', 'The Victoria'. Behind The Victoria was an establishment that for some years had been a lodging house for the 'more respectable' pedlars etc.

There are many superstitions concerning 'through ways', ancient habitual pathways. Perhaps 'The Victoria' had been extended across such a place?

But it is more usual to simply see figures and other things in such locations, it would appear, in this instance, that the witnesses became part of the scene, all be it-momentarily.

What triggered it? The 'time gap', of one hundred years – could that be that significant? We will probably never know.

MURDER AT SOUTH END

South End is said to be haunted by the ghosts of a murdered family. This is an horrific tale, telling of a man dispatching his wife and children with an axe.

THE KILDARE COURT BOGGLE

The Kildare Court Boggle is one of a number of Cumbrian boggles, whose visitation is said to herald disaster of one sort or another.

There is an eyewitness account, of an accident, that followed an appearance of this feared boggle, during the 1880s.

This accident occurred during the building of the Conservative Club, now, The Kildare Hotel. Blocks of dressed stone were being hoisted up the front of the building, via, a block and tackle. A Mr. Johnston jumped onto one of these blocks – not an uncommon thing to do, as it saved a climb up the scaffold.

The supporting chains broke at a height somewhere between 50 to 80 feet. Although managing to land on his feet, the unfortunate Mr. Johnston died of internal injuries a short time later.

THE SUICIDE ROOM

The Crown and Mitre is on Carrick's List of Inns for around 1860. Later in his 'History', he says that the present Crown and Mitre 'replaced a smaller building'.

When one building replaces another in this fashion, it makes the likelihood of a 'sealed' room a distinct possibility. There are a number of examples, and in some legends, secret and sealed very often go hand in hand.

But in all that I have heard of the Crown and Mitre, the description of a 'sealed' room has been very distinct. This bedroom is said to be known as the suicide room, as weird noises are said to issue from it and its influence also seems to at times encompass the room next door.

On one occasion, a landlord's daughter who slept in the adjacent chamber, touched a clammy cold face when she reached for a candle.

Of those locations mentioned; The Victoria, has been re-furbished and is due for re-opening as I write. The Kildare Court is closed. The Crown and Mitre is now a travel agents, and The Kings House is closed.

COAST

North West England's stunningly beautiful Solway Coast stretching from Port Carlisle to Ravenglass, is, not surprisingly, a much haunted stretch of land and sea. Alongside contemporary happenings and ghost stories, there are traditions and reported sightings of generic creatures, including mermaids, which have persisted well into modern times.

In parts a coast of quick sands and fast moving tides, the Solway has, and still does, attract generations of both tourists and locals who appreciate the wildlife, wide beaches and glorious sunsets.

Cumbria has many locations that are traditionally said to be associated with King Arthur and his Knights. One of the most famous though paradoxically, often forgotten or ignored, are the remains of a chapel said to be the haunt of the Green Knight, which overlooks the Solway in wild isolation. Situated on Grune point it is, sadly, now mostly covered in modern concrete meant to hold a gun placement. But it still has the feel and reputation of a haunted place.

MARYPORT

Originally a small fishing village on the shores of the Solway, the present town of Maryport was planned and built by the Senhouses, local landowners and ship builders, and named for Mary Senhouse.

But this small town with its lovely Georgian houses has a fascinating and historic past as Alauna, Roman Fort, Port and Vicus.

SOLDIERS

The Roman Senhouse Museum, originally built as a battery during the Napolionic wars, has, I believe, one of the finest collections of Roman altars and grave markers in the country. So many must have lived their last in this far post of Empire, but their stories, tragedies, loves, remain for the most part frustratingly unknown to us.

On the land side of the museum is Camp Field; a Roman Fort lies just beneath its surface.

It is hardly surprising that there are a numbers of local stories concerning sightings of Roman soldiers on the brows and shoreline around Maryport. Times of day and numbers of figures vary. Sightings would appear to be irregular yet frequent, and encounters remarkably similar.

One very recent encounter was on the brows very close to the Senhouse museum and Roman Fort. A local woman was out with her dog taking their regular late night walk along the brows on the shore side of the museum building, which was on her left. It was a light clear night, with no cloud and a bright but not full moon. She could see the museum and most of Camp Field clearly. As she approached she became aware of some figures in camp field, a small group of solid figures, possibly close to one of the fort's gateways.

They were dressed as Roman soldiers, although individual clothes varied slightly, and she could see colour even by moonlight. She commented afterwards that if it had been daylight she would have taken them for re-enactors. It was checked and there were not, nor had there been re-enactors on site around that time period.

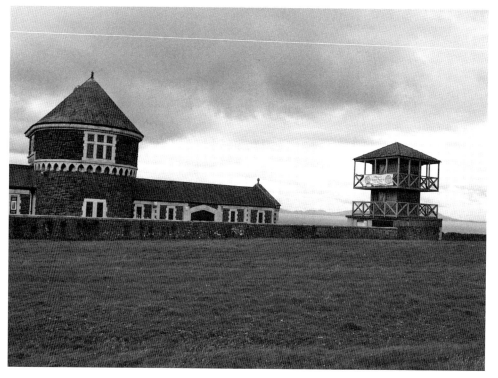

Senhouse Roman Museum and watch-tower.

The brows path.

It made a lasting impression, and, I am told that the person in question changed both the time and route of her dog's evening walk.

THE WHITE LADY OF CROFT PIT OR THE RED BANK BOGGLE

The story of Croft, or to be more accurate, White Croft pit, is a fascinating fusion of both ghost story and folklore. There is also the locally held, possibly contentious belief, that the White Lady of Croft, also known as the 'Red Bank Boggle' was the inspiration behind Wilkie Collins' *The Woman in White*.

There are a number of versions of the White Croft haunting, but most accounts agree in the main detail. This leads to the evident conclusion that there is probably more than a little truth somewhere within the basic story.

Sometime around the middle of the nineteenth century word began to spread that the engine house at White Croft had begun to receive regular visits from a headless apparition, wearing a white silk gown. According to some accounts, the rustle of her dress was almost as terrifying as the apparition.

White Croft was on Red Bank, between the costal village of Flimby and Ewanrigg, Maryport. Ewanrigg Estate is also involved in one of the many Cumbrian 'Golden Coffin' stories, stories that describe the coffins occupant as a chieftain, or, a woman, admittedly a Roman woman, in a white silk dress.

However, none of the colliers involved appeared to have had any thoughts as to the identity of this truly frightening lady. Although at first seen only by the engineman, within a short space of time she had appeared to many others, who were uniformly terrified, and who can blame them.

Hewing coal was dark and dangerous work, and those men who slaved in the galleries were, hardly surprisingly, a superstitious breed. Some miners refused to work in Croft, and eventually there was only one who would man the engine house at night.

Apparently, at the outset of the haunting, the apparition had always appeared outside the doorway of the engine house, but eventually she turned her attention to the building itself and began to enter. On one occasion pointing to the engine, then disappearing.

As the colliers were being drawn up at the end of the subsequent shift, the winding engine went out of control and some men were killed. At least one version says that the engineman also lost his head.

There are a number of accounts of Crofts silk clad entity going underground, and being seen and heard in the galleries. It is has also been said, that on one occasion the White Lady was followed by a boy, who was later found dead.

Here the story begins to take on some aspects of 'Spirit', the 'Lady' of the mines, although, she is not traditionally headless. West Coast folklore firmly states, don't follow the lady, to follow her is death. At one point *don't follow or speak of the Lady* was almost a mantra. It is also believed that grown men can escape her, but that she takes the souls of children.

This fits in well with Croft pits White Lady being seen underground, and that the only apparent death as a result of these underground visitations traditionally appears

to be that of a boy. It is possible that a pit head haunting has become entwined with the superstitions surrounding, what would at that time, have been a well known underground entity.

Whatever the truth, White Crofts silk clad headless ghost has the distinction of closing the colliery down. Eventually, in spite of being offered higher wages, no one would work there. Who can blame them? For headless ghost or 'Spirit' of the mine, death appeared to attend them.

The background of the 'Red Bank Boggle' aspect of the White Croft haunting, is relatively simple and brutal. A local girl who lived with her parents somewhere along the pathway between the site of Croft pit and Ewanrigg, was murdered.

Late one evening she had set out alone to bring a doctor from Ewanrigg, to attend her sick father. She didn't return, and was found some time later in a small stretch of woodland. Her head had been taken from her body, it was eventually found, but her killer was never brought to justice. Locally this event, probably because of the manner of the girls death, is taken to be the beginning of the Red Bank Boggle, a lady in white, and usually regarded as the same entity that haunted the engine house of Croft pit.

All in all, this is an area that appears to be replete in 'White Ladies', headless or otherwise. For Ewanrigg Hall and its surrounding estates, are also said to be haunted by a woman in white. Depending on whom you read and when it was written, this woman is identified as, the Red Bank Boggle, the White Lady of Croft Pit, or a separate entity, with a so far, unknown story and identity.

It is a long time, perhaps too long, since I read Wilkie Collins *The Woman in White*, there have been and are a number of local commentators who believe that Ewanrigg Hall, is the setting and inspiration for Collins' novel.

A number of people have looked at Collins' book in some detail and claim to have identified particular sites within the county with his descriptions. There is, sadly, no apparent evidence of a visit to Ewanrigg Hall. Collins and Dickens did visit Cumbria, then Cumberland, in 1857 and seem to have been enchanted by the Solway coast, and Allonby. As a result of this tour a joint book was published *The Lazy Tour of Two Idle Apprentices*. That classic *The Woman in White* was published some three years later.

It would have been interesting, if any or all, be there several or one, of the Ewanrigg/ Red Bank White Ladies, had been the inspiration behind such a book.

WHITEHAVEN

The name Whitehaven possibly derives from Old Norse and could be 'haven by the white head'.

The town sits on the northwest coast of Cumbria, on the shores of the Solway, and it appears to have began as a designated port, in which exclusive rights were held by monks. There was a priory just a few miles down coast at St. Bees. In more modern times Whitehaven eventually ranked as the third busiest port in Britain,

Developed mainly by the Lowthers, mine owners, shipbuilders and it is said, slavers, the present town is relatively modern, with many fine Georgian buildings, that are, for the most part, well preserved.

THE GIRL WITH THE CANDLE

The location of this sad ghost varies slightly. Some say that she is seen in Lowther Street, one of the main shopping areas of the town, others say that she walks the old market square.

Both areas are within a few hundred yards of the sea, and as the cause of her plight appears to be the loss of her seaman lover, perhaps she appears in both locations.

She is seen in daylight, solid, in full colour, wearing what appears to be a nightgown and carrying a candle. This apparition appears totally oblivious to the modern world around her.

The original story appears to be eighteenth century. There are slight variations, but the bulk of it is remarkably consistent.

A wealthy merchant's much loved daughter fell in love with a young man who was below her social status, in spite of this the couple begged permission to marry. Incensed, her father had the girl confined to the attic of his large house.

Using a maid as go-between, the lovers made plans to elope – hopefully gaining passage on one of the many ships that passed through this busy port. A lighted candle was to be the signal and a rope had been smuggled in to help the girl's escape.

The window of her prison was high, and whether from nerves or lack of strength, as she had been confined for some time, the girl slipped and fell to her death at her lover's feet.

Another version of the story tells of the lover been bribed or kidnapped and placed onboard a merchant vessel. Thinking herself deserted, the girl jumped to her death.

Dickinson has a version of what is very likely the same basic, or root, story. It tells of a large house that was situated 'opposite the west end of the present market house'. (This was described in 1875). The daughter of this house was found dead one morning, beneath her bedroom window, and foul play was suspected.

The night watchmen at the end of the eighteenth century were convinced that the streets of Whitehaven were haunted by the totally white apparition of a tall young woman.

She was said to be a quiet, gentle ghost, sometimes seen on the edge of the town, and also on the quays and harbour. But more often she was seen disappearing into alleyways and dark places as though she was afraid. The watchmen were of the opinion that it was the ghost of that same Miss G. who had been found dead beneath her bedroom window.

This haunting went on for some time, and it appears that the house from which the mysterious Miss G. was said to have fallen itself became haunted. This haunting of noises and lights, was said to centre itself on one mysterious darkened room, and a terrified servant reported seeing a young man there. She appears to have been reassured that this gentleman was a guest not a ghost, and had 'the confidence of the family'.

From here onwards, you get a sense of 'arrangement' in this version of the story. A Revd Wilfrid Hudleston agreed, somewhat unwillingly, to lay the ghost that was troubling the house. Unwillingly, because there is an ancient superstition, and this is pointed out by Dickinson, that there is a price to pay in laying a ghost successfully. This price is usually a loss of one of your faculties or senses.

The Revd subsequently waylaid this young man (or ghost) on one of his nightly perambulations, and after some persuasion, apparently succeeded in laying his spirit beneath a large mulberry tree in the garden of the house. From then onwards the house was reported to be peaceful.

There is no record of any loss of faculty in relation to the Revd Hudlestone, and interestingly, there is no more mention of the deceased girl.

There are so many connotations and possibilities within this tale. Tradition tells us that the family of the house had large plantations in the West Indies, and stood 'high in mercantile matters'. Also, it appears that a young male member of the family went missing shortly after the girl's body was found. His disappearance was never fully explained to anyone's satisfaction.

That there is a story here and a fascinating one, ghostly or otherwise, there is no doubt. We will probably never know the truth.

One thing persists. A lonely girl oblivious of the modern world, still walks the streets of Whitehaven in a vain and endless search for her lover.

THE 'FANCY DRESS' GHOST

This is a strange story, with little detail, but well worth recording. Its possible date is around the mid nineteenth century.

There was a small mission somewhere within the Whitehaven area, attended by miners and their families, all who lived in small cottages near by.

It is said that these homes were haunted by the ghost of a man who knocked on the doors, before appearing in the living room or bedroom. This spectre wore a different period costume each night he appeared.

To date I have not come across any other account or experience generically, or remotely, similar.

SKINBURNESS

Just south of Moricambe Bay, take the B5300 to the town of Silloth, then follow the signs.

The Solway is a place of legendary storms, one of the most famous, or infamous, swept a village away overnight. Skinburness was a thriving port, possibly by the standards of it's heyday, a small town, It had been granted its market charter around the twelfth century.

One night in 1302, the town was swept into the sea by a ferocious storm. Some accounts say a single wave took it, buildings animals people, never to be seen again. I am led to believe that the present Skinburness is some distance away from the site of the original, a wise decision on such a treacherous coast.

LOST LOVERS

I think that most people are familiar with the reputation of Gretna Green, and the previously differing marriage laws of Scotland and England, which led to many clandestine unions, and are now a thing of the past.

There was a ferry route between Skinburness, and a place somewhere between Annan and Gretna. There were occasions when the tide and the Solways infamous shifting quick sands dictated the exact landing place. Taking into account the possible date of the legends, this crossing still existed long after the original Skinburness disappeared beneath the waves.

It was a hazardous crossing, but one that those desperate enough braved in the worst of weather. Not everyone succeeded. It is said that on certain stormy nights it is still possible to hear the heart rendering cries of drowning lovers.

GHOST SHIP

There have been countless shipwrecks, ancient and modern, in the Solway. When I was a child I remember being told of many non-specific ghost ships that were said to haunt the Solway tides.

It is hardly surprising that a sea with such a history should have many apocryphal tales, tales in which the detail has been forgotten and mere shadows of the originals have survived.

But some stories do survive in reasonable detail, one such is that of the *Betsy Jane*. She was returning to her home port of Whitehaven, loaded with gold and ivory said to have been obtained with profits of the slave trade.

This ship, with all hands and her cargo, became a victim of a Solway storm just a few miles out from her home port. It is said that the *Betsy Jane* is seen in stormy weather around Christmas time, some accounts actually say Christmas Eve. She is seen going to grief and the cries of her crew are clearly heard.

SPIRIT OF THE MINES

There are, or perhaps I should now say, were, many mines in Cumbria, some extending far beneath the Solway. 'Spirit' or 'The Lady of The Mines' was a widely believed, now almost forgotten, traditional phenomenon. Cumbrian legends and stories of 'Spirit', or at least those that are still remembered appear to have attached themselves, chiefly, to these coastal areas.

This possibly could be just a matter of memory, for the entity known as Spirit is, or was, also known to miners on the East coast of Britain, but these incidence usually differ from the northern tradition in one specific and important aspect.

In the East she can protect, in the North, she usually kills, yet it is possible to escape her. It is however sad but true that this beautiful entity appears to hold the promise of death in her grasp wherever she appears.

The Lady of the Mines appears as a beautiful woman dressed in flowing white. She has long golden hair and exudes a smell of violets or roses. She is seen in the deepest and darkest galleries and was said to comfort dying children.

Tragically often children would be found, curled up, rosy cheeked and smiling in death. It is hard to imagine the life these little ones must have led, hours in the dark, often alone and too often cruelly treated. Thankfully, this is a thing of the past, but let us not forget them.

There are accounts of adults who have seen the Lady, but very few appear to have been recorded, those that have been are usually within families. Stories and incidence are more often passed on by word of mouth and are becoming rare.

Part of our northern tradition says that adults can and at times do, escape the lady. One account I was given personally and verbally comes from the beginning of the war, so this entity must still have been known and spoken of then.

I record it with thanks and without name. This account concerns two brothers, both were colliers in one of the Solway off-shore mines. One day when they were both on the same shift, there was a roof fall.

The gentleman who related the incident had managed to get out relatively quickly. His brother had been deeper and it was some time before he was brought to the surface, having part crawled then finally been carried to the cage.

This brother swore he had seen the Lady and escaped her, also that she had been seen by others in the same gallery.

Our northern tradition says to follow the Lady is to follow death. The east coast tradition says she can lead you to fresh air and freedom.

SOLWAY SANDS

There are many stories told about the ever-changing sands of the Solway, sands that are always beautiful and often dangerous. There are banks and patches of moving quick sand that can change location with the tide. It is said that were you to be accused of witchcraft, you were thrown into the quick sand if you were lucky, or burnt if you were not.

THE BROTHERS

One of the oldest most persistent stories concerns two brothers who lived near the head of the Solway. For unknown reasons these men were vicious rivals, this rivalry came to a head in a quarrel that resulted in the death of one of the brothers.

Some versions say that one brother murdered his sibling by stealth, other versions that they agreed to fight to the death. Whatever the truth, it was necessary to dispose of the body. The surviving brother decided to wait until the tide was right and then to drop the corpse into quick sand. The body was kept well hidden and when he judged it time he slung his dead brother across his back and walked out over the sands.

On reaching an appropriate place it became clear that although he may have judged the tide well, other timing was out of place. For the corpse had stiffened with rigor mortis and try as he may he found that he could not release his brother's body from his own.

Panic began to set in, the tide was turning, the fast and dangerous Solway tide. He tried to head back to shore, but his burden made his journey painfully slow as the water quickly rose, lapping first his ankles, then knees as the sand moved beneath his feet. At last he was overcome and he drowned, twisted in the unforgiving clasp of his sibling's unrelenting corpse.

At certain times these rival brothers have been seen, the ghost appears, in shape, like that of a lumbering monster with an second head sprouting from its back.

SHORELINE BOGGLES

Cumbria and its adjacent shorelines were for generations the territory of smugglers, it is well accepted that many old smugglers routes are haunted. It is a possibility that in the past tales were spread about these tracks and byways as part of a deliberate ploy to keep the curious away from 'places of business'.

A very specific and vicious generic type of Boggle is associated with the coastline of Cumbria. This 'type' of boggle is described to be half as tall again as any man, with

a body that consists of long black, dank, foul smelling strands, enormous glittering red eyes, sharp curving claws and pointed canine teeth. This monster is said to attack viciously leaving dreadful wounds, some of the older traditions say that this creature can and does kill. Interestingly, when visiting a heritage site a couple of years ago, I was told that a similar beast was once said to haunt the shores as far down coast as Morecombe Bay.

It has been suggested that the 'long foul smelling strands' could be seaweed, and that there was a man inside the monster, guarding the smuggling routes. Some routes were guarded viciously, and not by the supernatural. However, old events leave their mark and many stories persist involving traditional smuggling routes and haunts. This is hardly surprising when we think of the dark, dangerous and superstitious world of the past, old events and fears leave their mark.

There have been descriptions and sightings of these 'beasts' well into modern times, one of the most recent attacks dating from the 1930s. The victim was found battered, torn and close to death, and he apparently described his attacker as the Shore Boggle.

I am led to believe that there is a contemporary newspaper report of this incident, but thus far I haven't managed to track it down.

GHOST HORSES

Ghost horses are among the oldest and most persistent folklore of the Solway sands. They are magnificent magical creatures that are said to ride the edge of the racing Solway tides, to capture and tame one is said to bring great power and wealth, paradoxically, it is also said to be impossible.

The Solway sands and their swift tides hold many mysteries, at the top end of the Solway it is said, and with a degree of truth, that the tides come in at the speed of a galloping horse. There are apocryphal stories of men testing their mounts by riding ahead of a turning tide with the sea foaming at the animal's heels. This is probably how the stories of ghost horses began.

The myths say that long ago racing on the sands was a popular form of sport and wager. Fine horses, money, lands, it is sometimes said, women, all were won and lost on the results of these events. There were however times when some participants were tempted to 'race the tides', laying wager that they could outrun the sea by galloping ahead of the turning tide and reaching the tide line ahead of the water.

I am told on good authority that this is not possible, for the sand softens ahead of the encroaching sea and this would slow the fastest of animals. Falling, drowning, being caught in moving quick sands, any and all of these are a probability and only the fortunate would escape with their own lives and that of their mount. It is the unfortunate victims of such races that are said to haunt the Solway shoreline.

When the sun lies low and the sea is golden – then the ghost horses are seen. Some of these magnificent creatures are said to have riders, others gallop alone, plunging through the waves of the shoreline, that magical border between land and sea, their manes flying as they gallop through the foam, outrunning the wind.

Sometimes these wonderful creatures can be docile, and stand tamely on the sands, waiting. At such times it is said to be possible to mount them, and experience the ride of your life, or death. It is whispered that those who have dared try and have succeeded in mounting one of theses fantastic animals, were never seen again.

It is and has been suggested that smugglers were in the habit of spreading tales of ghost horses to keep unwanted visitors away from the beach. For such a ploy to have been effective, the stories must have been generally known and the creatures feared.

We appear to have retained a somewhat romantic picture of smuggling in the past, but in reality, it appears to have been a vicious trade, the 'Excise' men giving and been given no quarter.

Are these horses still seen, or spoken of? I recently met a gentleman who told me that as a child just after the war, he was instructed to be off the beach by sunset or he would be taken by the ghost horses.

SEA WIFE

There, on the Solway
When the sun lies low
And you can scarce tell the difference between land and sea
There, on that line of silver
Sea Wives rise…

Above the Border, they are called, Kelpies, Sealwife or Silkies, here the stories and legends have fared better than in Cumbria, for on the Scottish coast these beautiful creatures are still remembered. Well into the turn of the nineteenth/twentieth century, there were said to be sightings of mermaids in Luce Bay, which lies across the Solway from Cumbria.

Along our Cumbrian coast, we have the Sea Wife, down coast around the Ravenglass Estuary (although still in Cumbria) the sea creatures' legend has somehow become entwined with the three Queens that were said to carry Arthur to Avalon. This cross association is tentative but interesting.

A theme that these creatures all appear to share is the ability to move back and forth between the mortal realm and a magical land where time behaves 'differently'. Allowing them to return to their magic realms for years, sometimes generations, and to reappear with barely a sign of ageing. This ability appears to be shared with the legendary 'Fairie Wives'.

It has often been commented that this re-appearance after long absence, and lack of ageing, is an effect we can expect from long deep space journeys.

Once upon a time, paradoxically, among the most welcomed and yet feared mythical creatures of the Solway, locally the Sea Wife is now barely remembered. No complete stories appear to have survived, but there are those who can still recall scraps of Sea Wife legends from their childhood.

Our great grandmothers and even the generations before them knew of and dreaded these fabulous creatures, for of all the traditions concerning such entities, those of the Solway were the only ones constantly, though not always, associated with death. This

is hardly surprising, considering that well into the eighteenth and possibly nineteenth century, young men who were lost on the Solway, and whose remains were not recovered, were usually thought to have been taken by these enchantresses.

Losing a loved one and finding no body, perhaps there could have been a kind of comfort imagining them in a mythical land with a beautiful wife.

Sea Wife or Sea Wives, are, or were, an integral part of the legends, myths, hauntings and unexplained happenings of the Cumbrian coast. A mythical creature, perhaps, but people of past centuries not only made claim to have seen them, to deliberately keep watch and see them rise from the sea, but to be themselves, or to know of people who were descendants of the Seawife. As this apparently had the advantage of protecting you from drowning, it had to be a plus factor on such a dangerous coast.

They are women of wondrous beauty – it was believed that a mere glance from a Sea Wife's shining eyes was enough to enslave a man. This can't have gone down well with the local ladies and apparently, people have been accused of being a 'Sea Wife'. In a society where to be accused a witch meant either quick sand or burning, to be accused Sea Wife hardly bears thinking of.

Generically similar to Fairie Wives, Sea Wives sometimes chose to live for a time in our mortal realm, and to marry mortal men. They would leave their husbands periodically, sometimes for years, and return expecting their spouse to have remained faithful. Such a wife brought great fortune, happiness and success, so long as the husband did not betray them. Which of course being human, they usually did. After such betrayal the wrath of these creatures was legendry.

Sea Wives are said to pass between the mortal and their own realm by the means of a magical cloak, (in Scotland this is a seal skin,) to find and retain such a garment is to have its owner 'in your thrall' and bound to obey and protect you, with or without the bounds of marriage, which they regard highly. If you are fortunate (or otherwise) enough to encounter one of these wonderful creatures, beware, and treat her well. For if in danger or threatened, her sisters will come to her aid and the Sea Wife's power is mighty.

They are well capable of creating havoc, wrecking boats, devastating crops. Also, if they are betrayed they will kidnap any children of the mortal alliance, returning again and again to take any other children of their mortal husband/lover, if he should live long enough to sire more.

Although we appear to have forgotten most of ours, there are variations of 'Sea Wife' in many parts of the world, and as in all myth, there is probably a start point, a grain of truth somewhere? Perhaps from a time when the young, including children, were kidnapped as slaves or wives?

As to 'long ago and far away' there is an apocryphal rural myth from before the First World War. Sometimes it is accredited to an island off Cumbria, at other times, the Western Isles. It concerns an older man and a young, wealthy wife. The woman disappeared, and on investigation the husband declared her to be a 'Sea Wife', and that she had returned to her realm. His reasoning appears to have been accepted.

A word to the wise, gentlemen, if you walk our wonderful coast line on soft summer nights, take care and beware beautiful woman who don't leave footprints in wet sand.

Remember, treat them well.

THE LUCKS OF CUMBRIA

The Lucks of Cumbria, or the Cumbrian Lucks, are intriguing to say the least. For centuries they have been the subject of superstition, and speculation, they have been much written about and, those that are still known to exist, are treasured and, in some instances, almost revered.

In the past it is likely that some of these wonderful objects were regarded as holy. It is possible that they could be 'christianised' pagan relics among them, sadly, anything other than informed speculation, is almost impossible.

One of the most comprehensive lists, and some of the best descriptions of the 'Lucks', that I have ever seen, are by the wonderful Marjorie Rowling, in her book, *The Folk Lore of the Lake District*. She also has more information within one volume, than any other author I have read. She writes of Burrell Green, Edenhall, Haresceugh, Nether Haresceugh, Skirsgill, Rydal Hall, and of course; Muncaster and Workington.

These 'magical' artefacts, as they have been described, divide fairly easily into two basic categories. Presented by a monarch, given in return for loyalty and service. The gifts of fairies, or other supernatural beings, even when other origins have been 'proven', superstition lingers on.

The most widely known Lucks in modern times are probably Muncaster and Workington. I did several broadcasts on the Lucks some years ago, and certainly found that this was the case. Edenhall, and Burrell Green, were also much commented on. Edenhall is accepted as being the oldest artefact.

In W. Armistead's, *Tales and Legends of the English Lakes*, he mentions the poem by J. H. Wiffen, 'The Luck of Edenhall', and also prints a full version of 'The Drinking Match of Edenhall'.

THE LUCK OF MUNCASTER

This, as is well known, is a glass bowl or dish, decorated with a pattern in white enamel. This, we are told, is a sophisticated technique, and the dish must have been valuable in its own time, now of course, it is priceless. How could you judge the value of such a treasure?

Henry VI was given shelter at Muncaster, after defeat at Hexam. The story is, of course, famous. The King had been turned away from Irton Hall, and the then Lord of Muncaster could have been placing himself and his family in some danger by sheltering Henry.

On leaving, King Henry presented what was to become known as the Luck of Muncaster, to Lord John Pennington. It is said that the king's blessing and protection went with the gift. It is also believed that as long as this bowl is kept safe and remains unbroken, the family will thrive. The Pennington's line continues, and still resides in Muncaster Castle.

There is also an old local belief/superstition that some magic or power is attached to the bowl. The fact that Henry was known to be a devout and Christian man, and the manner of his death, have probably all added to the mystic of the Luck.

THE LUCK OF WORKINGTON

This luck is made from Agate, and is a small bowl, or goblet, with a short-stemmed foot. There are local stories that Mary used this as a travelling communion cup, which in turn would class it as a chalice. A chalice, that had possibly, been used in Queen Mary's daily sacrament, a queen who became a martyr. It would be well nigh impossible to prove this.

The more commonly accepted story is that this cup was brought from Dundrennan Abbey, where Mary and her companions had sought shelter after the battle of Langside.

On her flight across the Solway, Queen Mary and her followers were given shelter at Workington Hall, home of the Curwens. Lord Henry Curwen was absent, so the Queen was greeted, and made welcome, by the ladies of the house. There are many stories, possibly with some truth in them, of the queen's 'dire need' in regard to her clothes. It is both documented and accepted that Lady Curwen supplied Mary with fresh linen.

It is more than likely that the cup was presented to Lady Curwen, and not to Henry Curwen, as is so often quoted. The cup is still in the position of the Curwen family, Workington Hall is now a Grade I listed ruin.

THE LUCK OF EDENHALL

A superb glass vase enamelled in blue, green, red and gilt, this is one of the 'fairy' lucks of Cumbria, it has proved to be, in origin of manufacture, certainly the oldest of the Lucks of Cumbria. Marjorie Rowling suggests, that Edenhall's Luck might also have been used as a chalice.

Now in the British Museum, the vase is described as being of Syrian manufacture. A number of the Lucks, are thought or, have in some cases been proven to be of eastern origin.

This reminds me of the 'Fairie Flag' of Skye. This was given as a protective charm to one of the Lords of Skye, when he parted from his 'Fairie' wife. (Such wives are only allowed to mortal men for a certain period, and, if treated well, bring great good fortune).

Legend tells us that this original flag has been carried before the Clan McLeod in ancient battles. Now it is thought of as too precious, and never leaves its castle home This flag itself is now almost white with age, but traces of dye have been discovered that appear to show that it was once probably emblazoned with a crescent moon, and could have been eastern in origin.

This Fairie Flag is still so highly prized by the family, and has been regarded as so protective, that photographs of the flag have been carried by family members through both World Wars.

It might appear strange to mention the Isle of Skye in a book about Cumbria, but in the past, the Border has been a moveable thing (which is an understatement). Our Folklore has many similarities, and the Fairie Wives have many parallels to our north coast Sea Wives.

The Edenhall Luck differs from most others in that it appears not to have been a gift. The legend of its origin tells us, that it was taken from its fairy guardians.

Edenhall is a parish near Penrith. The Hall, now demolished, was the home of the Musgrave family. In the garden of the Musgrave mansion was a well, named for St. Cuthbert.

The family butler had gone to this well to draw water – some versions of the story say that he went at midnight, or in the moonlight. Why a butler should be doing such a thing, and at night, is not explained. He came upon a company of fairies, dancing around a magical goblet. Seeing its beauty, the butler grabbed the goblet, and the fairies were unable to retrieve it. (Are we being told here that it has protective qualities?)

Eventually, realising that they had lost their treasure, the fairies vanished, crying...

'If that glass should break or fall
Farewell the luck of Edenhall'

There is a common belief that the Musgraves died out, and that their home was demolished, because the goblet was lost or smashed. As mentioned earlier, the goblet now resides safely, in the British Museum.

THE LUCK OF BURRELL GREEN

Burrell Green is in the parish of Great Salkeld. This luck is a brass dish of around 16/17 inches in diameter. Highly polished and greatly treasured, this must be somewhat easier to keep safe than a glass dish or goblet. This dish has been also been ascribed, associated, with magic. There is a well-known tale of it falling down on three consecutive occasions, when the farm which is its home changed hands.

The traditional story of the dish's origin, is in many ways similar to Edenhall, in that some versions involve a butler. I admit to sometimes suspecting a little Victorian

addition, and/or alteration, when I come across such a version of a legend from a time when a 'house steward', would be more likely servant, than a butler.

The Burrell Green Luck, is said to be a wedding gift. It is said that a wedding feast was in progress, and a group of hobgoblins appeared to a servant, (some versions say butler) that had been sent to draw water from the well. The hobgoblins asked for food and wine, declaring that in exchange they would bless the wedding.

The food and wine was brought, and the hobgoblins feasted, the dish and all that went with it was given in return.

Rowling comments that the present house was either built or rebuilt in the seventeenth century by a man named John Burrell. She goes on to tell us that there is a Burrell Green of the same period near Penrith. The mention of Penrith is interesting, for stories of brownies, goblins, hobgoblins, and the like, are much more common towards the east of the county.

Sadly little is known about the other lucks, Armistead, mentions a pear in a silver box, if this is a wooden, or silver fruit, or even a preserved real pear, he does not say. The location is also a puzzle, as I do not know of any Haddington in Cumbria. However there is one in East Lothian.

Harescueugh Castle, is no more – its luck was said to be a wooden bowl, and this has disappeared. Perhaps in this case, the superstitious could say that one triggered the other.

It is likely that Skirsgill Hall's has been sold. As to the others, I would like to hope that they still exist, as I have, so far, been unable to unearth any really up to date information.

Perhaps we will never full know the complete stories behind such fascinating artefacts, and they will remain, in some part, true enigmas.

THE RIVER DERWENT

There are several rivers named 'Derwent' or Oak River/ River of Oaks the name itself gives some clue as to how long this title has endured. Oaks were beloved of our ancestors, featuring in the beliefs of both, so we are led to believe, the Celts and Druids. Oak groves, especially ancient groves that have seeded and re-seeded themselves over countless generations, still hold their magic.

That river Derwent which meets the sea at Workington on the Solway coast, appears, sadly, to have lost most of the majestic trees that must, originally, have given this fine river it's name. However the stories persist, old and new, some of which are recorded here.

Below the steep bank of Workington Hall there is a stretch of fine parkland named Hall Park. A stream and fence divide this from a large meadow, Mill Field, It is through this meadow that the Derwent sweeps on its final swift rush to the sea. A river much used by local people, it can be and look innocuous, but in nature it is fast and deep, I am told one of the fastest rivers in Europe. The meadows of Hall Park and Mill Field are popular with walkers, with and without dogs, cyclists, runners, fisherman, local families, who are in turn all much appreciated by the well-fed colony of swans.

A copse road runs down the Hall bank across these meadows and park land on its way to the ancient church at Camerton which lies across the river. An ancient 'through way' also crosses these lands, more of which is mentioned later in this book.

How often things are 'seen' is difficult to quantify – stories filter through; I am told of one dog walker who has seen the grey lady so often, they avoid each other and say nowt! The Yearl, that part of the river which lies just above the bend featured in this next tale, is both deep and dangerous, over the years it has claimed many lives, both by accident and otherwise.

THE MILKMAN'S TALE

This story was told to me by a former family milkman. He was, and I am sure, still is, extremely knowledgeable in respect of local tales and histories. So here I grant him not only the anonymity he requested, but also add my sincere thanks.

Right: Recent floods have swept away the scene of this tale.

Below: Monk-like figures and a grey lady have been seen here.

Between them the beautiful and dangerous Yearl.

This story dates from just after the Second World War. Private cars were still uncommon and the Hall Park and its meadows were still a popular shortcut from the town to Barepot, a hamlet that lies on the north side of the Derwent. I am told that, in the past, there were times when it is was possible to cross a shallow stony part of the river just below the Yearl.

Even then, there were few people who would take this path unaccompanied from twilight onwards. At certain times of year mists spawn up from the river and the sight can be magical. It was taken for granted that figures were often seen – these were sometimes simply other people making their way to or from the town. But sometimes there were sightings less easy to explain. Workington Hall's infamous 'White Lady' is said to follow an ancient track before disappearing at the river bank. Also, monk-like figures regularly follow the old riverside path. It used to be said that fishermen sometimes saw them through the early morning mists.

Nevertheless, it was a popular and I am told at times, populous, courting venue, especially with couples making their way home after the 'second house' pictures.

I was told that it was a beautiful clear night with some wrag, though only about ankle deep, just beginning to roll from the river. On the north side of the Derwent, there is a stonewall that divides it from the Barepot road. A couple had just settled down on the field side of this wall, when they became aware of a figure on the opposite side of the water, crossing the Mill Field and heading in the direction of the Yearl which was just a few yards up-river from the place they had chosen to say their goodnights.

The figure appeared to have a folded sack over its head and shoulders. This was not unusual, so deciding it was a river watcher the lad urged the girl to keep quiet until the bailiff had passed by.

However the girl became uneasy as the figure began to approach what was in her opinion 'too close for modesty' she urged her boyfriend to make some protest. After all, they weren't out to take fish. The lad got to his feet and called out asking for some privacy, the figure turned and began to head directly in the couple's direction. The lad hurled a cobble – it went straight through the figure who continued toward them straight across the water.

Who got home first, I never found out, but I have been told since, that the courtship led to a long and happy marriage.

LAKELAND

WASDALE

Wasdale is a sombre and majestically beautiful valley that boasts the highest mountain, (Scawfell) and the deepest lake, (Wastwater) within the English Lake District.

With its towering mountains and deep mysterious lake (a favourite of divers), that in fair weather or foul appears to take on the colour of the massive steel-coloured screes, which, in certain light are often streaked with gold. Wasdale's chief beauty lies in its very wildness.

Even when full of tourists, as this wonderful valley often is, it appears to dismiss, ignore, and overpower these crowds, remaining always its aloof and magnificent self.

BURNMOOR

There are a number of famous, or infamous, corpse roads in Lakeland, deriving from past times when not all churches were granted licence for burial, and it was therefore necessary for some mourners to undertake what was usually a long and sometimes dangerous walk to the designated burial place. Coffins, and in more ancient times, bound corpses, were – depending on individual means – either carried or lashed onto horseback for this, their last earthly journey

Not surprisingly a number of stories exist concerning happenings and incidence on and around these bleak and often lonely, tracks. Most of which seem to retain the atmosphere of their original purpose. Few of these tales are as persistent as Burnmoor's.

The legend is old, undated, and concerns the Wasdale side of the Corpse Road between Eskdale and Wasdale. This road crosses Burnmoor, literally a moor wild and sombre; it begins at Boot in Eskdale passes Burnmoor Tarn and eventually, with mighty Scawfell to the right, and lake screes to the left, drops down towards Wasdale Head and its wonderful old church.

It was at the funeral of a young man, we presume of Eskdale, that the horse carrying his coffin took fright at some invisible entity, and bolted. Search as they would, the mourners were unable to find either horse or coffin. This event so distressed his grieving mother that she herself died shortly afterwards.

So it was that the mother's funeral procession very shortly followed that of the son, this time, legend states, taking place in mist and snow. The horse carrying her coffin bolted in the same place and manner as that of her sons. A desperate search was instituted, a search that found not the mother's but the son's missing horse and coffin. The son was taken to his resting place in Wasdale, his mother's horse and coffin were never found.

Ever since there have been reported incidence on Burnmoor, in the snow or storm, describing the thunder and vibration of hoofs, and a black horse with the sinister oblong of a coffin on it's back galloping past anyone on the Burnmoor path before disappearing into the mist.

Interestingly, it is not uncommon to see the story of Burnmoor written the 'other way around' as it were. Concerning a funereal party from Wasdale, walking to Eskdale. However this tale is recorded, Wasdale/Eskdale, Eskdale/Wasedale, all other details in the story hold true including the haunting of Burnmoor being on the Wasdale side of the corpse road.

A RELATIVE?

I have a late friend who had lived in Wasedale Head all her life to thank for this following story.

Some years ago she told me that a lady dressed in a crinoline appeared regularly in the bedroom of one of the family houses in Wasedale. My friend, I believe, had witnessed the apparition more than once. This lady appeared standing at the end of the bed, and on occasions walked through the bedroom wall.

On asking my friend if she knew anything more about this apparition or her story, I received a smile and the reply – 'I suppose she was a relative.'

WASDALE HALL

The grounds of Wasdale Hall run down to the lake's edge, and this beautiful house sitting on the northern shore of Wastwater lake, facing the stunning screes of Illgill Head and Whin Rigg, is now a YHA Hostel.

A hamlet was pulled down and cleared to make way for this lovely building and both this house and its setting, are locally renowned for being haunted.

I was fortunate in being shown around the Hall by Bob Shaw the Warden, who told me of a number of incidence occurring within the house itself. Most of the experiences appear to relate to the right hand side of the house, left side as you face the building.

A short time ago two residents were playing table tennis in the cellar games room, when they came up the stairs with some speed to say that a man had appeared in the corner of the cellar, and appeared to be contentedly sitting watching them.

Wasdale Hall.

The door leading to the cellar sits in a corner with another door at a right angle to it, Bob told me that this was a spot he had never liked, but had not been aware of any incidence there.

Another recent account concerns a large light ground floor room that is sometimes used for meetings. In the course of one such event, several people left this room saying how uncomfortable they had felt and asking if it was haunted.

One of the bedrooms, again on the right hand side of the house, had been split, one part being a dressing room that had had the door sealed, another door led to a flat and was kept locked. A girl who had worked in the hostel, had often commented that she didn't fell happy there, I sympathise with the feeling.

It is notoriously difficult to be certain of direction when we are speaking in terms of sound. But, this would appear to be the area involved in other accounts I have heard, that describe a woman sobbing.

All the events related so far are recent, (I believe within the last year) others I have had passed to me have been generated within the last five years or so.

A friend's son who was one of a group staying at the Wasdale Hostel, told me that a number of them had been kept awake by the sound of a woman crying. They were told that it was the ghost of Mrs. Rawston, grieving for her child. He has stayed there since, but refused further comment.

Another friend, on one of many visits to Wasdale, happened to be the only person in his dormitory. After settling down for the night he was awakened by someone coming

into the room and then obviously settling themselves down. He heard footsteps and bedclothes moving, then a bed creak. Afterwards he said he didn't know if he was glad or sorry he had kept his eyes closed, but there was no sign or sound of a light being put on and he did not really want to disturb or to be disturbed.

After what he described as a good night's sleep, he realised that none of the other beds appeared to have been slept in. This was not unusual, as people do get up and out early. However when he commented on the incident to the warden, he was startled to be informed that no one else had stayed there the previous night, in fact he had been the only guest in the hostel.

THE CRINOLINED LADY

Local lore states quite unequivocally that Wastwater Hall is haunted by a woman in a crinoline.

They say that her name was Isobell Rawston and that she her home was Wasdale Hall, and that Isobell had an adored small daughter who was drowned. We have no other information, other than the child was with a friend when the tragedy occurred, so it has always been presumed that the small girl either fell into or paddled out into the lake.

Where the ghost is said to walk.

Above: The woman in crinoline has been seen here.

Left: Few bodies are ever recovered from the lake.

Wasdale screes.

The door of Wrasdale Hall. Isobell has been seen here.

Whin Rigg, a scene of haunting.

Wastwater can be deceptive, in places it has apparently shallow edges where within a step you can be in ice-cold water hundreds of feet deep. The deepest part of this lake is at least four hundred feet, and few bodies are ever recovered.

After her loss the distraught mother constantly walked the lake shore, crying and calling for her child. She walked the moor like top of Whin Rigg that towers high and imposing opposite her home, it is said that she walked day and night, always alone.

Then, when she could take no more, inconsolable, Isobell walked out of Wasedale Hall and into the lake.

It is said that Isobell still walks the grounds of the Hall and has been seen leaving the door and walking towards the lake, mad with grief for her daughter.

Also she is often seen on Whin Rigg, a solid figure in a crinoline, the wind still blowing at her skirts and hair. Sometimes she has been mistaken for a member of a film cast, it is not uncommon to see cast and crews in Wasdale.

One rare account says that she has been seen on Whin Rigg walking with her daughter, so perhaps it was a favourite place?

GHOSTLY ARMY

There are a number of tales from various parts of the British Isles telling of ghost armies marching across the sky, one such event was said to be associated with the battle of Culloden.

The ghost army of Souter Fell is one of the classic tales of Lakeland, indeed it could be called a classic tale of the genre.

For those who are unfamiliar with the area, Souter, sometimes called Souther fell, with varying pronunciation, is a whale-backed ridge which lays towards the Mungrisdale direction of the Blencathera massive, above Threlkeld, on the A66.

Souter Fell's ghostly army appears to be unique in the fact that this event appears to have repeated itself on the same day, Midsummer Eve, for several years: 1735, 1737 and 1745.

1735. The first recorded event was witnessed, we are told, by a man named Daniel Sricket on Midsummer Eve of that year.

1737. A gap of two years, then once more there was an appearance on Midsummer Eve. This time the event was witnessed by a Mr. William Lancaster, plus his family and once again, Stricket.

1745. This time around twenty-six people witnessed the phantom army. Some years later two of these witnesses were to put their name to a document attesting to the truth of this event.

What did they see? This ghost army did not, apparently, appear in the sky, but had its combined feet well and truly on the ground, or so it appeared to the onlookers.

Each event lasted well over an hour, horses, men, and in one account, carriages, marched up and over the ridge of Souter fell, from the east, then disappeared into thin air. The ground was examined afterwards and no sign of horse or footprint, or indeed any unusual disturbance was found.

A number of commentators have suggested that the 1745 event could have been a mirage of a real army involved in the Jacobite rebellion. Historians say that the dates are wrong, and that April would have been a more likely time for any such army to have been on the move.

A view of Souter Fell and the ridge the 'ghost' army walked upon.

If it was a mirage, why were such oddities not seen more often? Why only on Midsummer Eve, why has nothing been seen since?

There is one report from the late 1770s of men and horses been seen to ride over a cliff and then apparently disappearing, since which nothing of note appears either to have happened or at least to have been recorded.

In later years the poet Wordsworth penned a line or two to commemorate the ghostly events, so it must have remained the subject of discussion and debate. There appears to be a great deal unsaid. How was the army dressed? Were they wearing garments contemporary with the dates of sightings? Was there any sound?

I presume that after the original reported events, some of the interested and curious visited Souter in the hope of witnessing other such momentous happenings. In later years was there any watch kept in expectation of a ghostly return?

We are left to wonder.

BASS LAKE

Bassenthwaite or Bass Lake, the preferred local name, is the only true lake in Lakeland. All other bodies of water large enough to be named, are either Tarns or have water or mere included in their name.

Bass lies just north west of Derwentwater, often incorrectly called 'Keswick Lake', in the past these neighbouring stretches of water were one, and there is evidence of ancient fortification on the shores and hills surrounding both.

THE LADY OF THE LAKE

The Lady of Bass Lake is an ancient and dateless phenomenon that has almost been forgotten. She is said to be seen on calm moonlight nights, a shimmering silvery figure, with flowing hair and garments, who rises whole from the lake and glides on it's surface. If there are certain nights, festivals, moon fazes or times when she is likely to appear, they have, sadly, faded from memory.

There is an apocryphal local tale concerning the poet Keats, it is said that he saw the Lady, when staying at Mirehouse, a house and estate on the shores of Bass, in 1818. It is interesting to speculate if and how much this apparition may have inspired him.

As far as I know there is no specific story connected to this beautiful entity. But, this area has had long association with female deity, which I am led to believe, lasted well into the nineteenth and possibly early twentieth century.

Like often follows like, and it is interesting to note that the lovely old church on the far side of Bass has a female appellation, somewhat unusual as male appellations far outnumber female. This wonderful church is named for St. Bega, the Irish Princess who fled to St Bees and founded a Convent there. Collingwood says that there are only two churches in the world named for St. Bega, Bass Lake has one of them.

The female deity this area was associated with was Brighida, sometimes, especially locally, called Brigg, Bride or Bridget and often confused with St. Bega, who is also sometimes known as St. Bridget.

Looking across the lake to Peelwyke.

Here 'The Lady of the Lake' is said to appear.

It has long been local lore, though this too is sadly fading, that the Church of St. Bega sits in the remnants of a stone circle and is an ancient worship site.

Surely this invites speculation – perhaps Bass Lake is haunted by the memory of an ancient Goddess?

A note of interest, Brighida was said to be Goddess of Smiths among her other attributes. The superb Emblton sword was found just North of Bass, on land that must have been flooded when both Bass and Derwentwater were one stretch of water. The valley where this wonderful artefact was discovered is still mainly marshland

PEELWYKE*

Perched atop a flat-topped rocky outcrop on the shores of the Northern end of Bass lake, between what was the railway and is now the new A66, and the Pheasant Inn, lies Peelwyke. Said to be the remnants of an Iron Age fortified habitation, this site overlooks the lake and has a magical reputation.

The fort is approachable from the old A66 now a side road that passes the Pheasant Inn, and was well sign posted. Although on my last visit, a couple of years ago, I gave up the uneven struggle with brambles and wire and did not gain the summit.

There are said to be fairies at Peel Wyke, small shadowy figures have been seen there within the last five years, but a local story states that the one of the last fairies in Cumbria was seen near here in the 1880s.

Dickinson has an undated account of a Thomas Bell of Thornthwait, who was born at Peelwyke. Thomas lived close to a family called Watson who had several young sons. These boys often played on the Castle hill of Peelwyke, one day they were digging into the side of this hill when they found a 'neat' hut roofed in slate. Unfortunately they were called back to dinner before their excavations were complete.

Rushing back to the hill as soon as they were able, the boys were startled to find no sign of their previous excavations, and search as they might they never found any evidence of the place again. Nor has it been seen since.

Thomas Bell also had a tale of the boy's father.

Around sunset one evening Mr Watson was in a meadow near Peelwyke, when he saw two tiny people dressed in green. Now Mr Watson had a bad-tempered dog, which he set onto these small beings, as the dog charged forward it fell, yelping and rolling. The animal continued to tumble and cry till it fell whimpering back at its master's feet. The little people were never seen again.

This atmospheric site also has the reputation of being haunted, but the details are none specific.

*Peel is defensive. Wyke is bay.

DEVILISH LUCK?

This tale describes a card game that took place in the inn at the Haws, and the players as people of the parish of Bassenthwaite. There are a number of 'Haws' within the Lake District, with a variety of spellings. Haws end on Derwentwater would be the closest to Bassenthwaite, but as to whether or not this area ever boasted an inn, I have so far been unable to establish.

Dickinson heard the original tale from a by a Mr. John Swinburn in 1829, so it is possible that there was a more local 'Haws'. According to Diana Whaley's wonderful book, *A Dictionary of Lake District Place Names* it appears that 'haws' could in some cases be used locally to refer to fellsides.

We are told that the people of Bassenthwaite parish were fond of a game or two of cards, indeed it appeared to be a favoured social pastime.

It was a Saturday evening and a number of gentlemen and ladies, all known to each other, had met with the intention of spending a pleasant evening with the cards. The game of choice was Loo, and the evening passed pleasantly, so pleasantly, that they were, unknowingly, still playing at well past midnight.

One lady of the company particularly known for her skill at the card table, seemed to have winning hand after winning hand. She played on oblivious of time, boasting, and with ever higher spirits, until eventually she held three aces in one hand of cards. Laughingly she commented on her cleverness, declaring that she was now a match for the devil.

Suddenly the company was disturbed by the sound of hooves and a sharp rap at the inn door. A man entered, looking every inch the gentleman and requested that his horse should be fed, stabled and given every care.

The horse was said to be a fine animal, coal black and well cared for. It appeared to have been ridden hard but was in general well behaved. In spite of this, the grooms declared themselves glad to have it fed and bedded down for they did not like the look of the beast.

The richly-attired rider was himself dressed all in black, and on seeing the company requested that he should join their game. As he seemed to be a man of good humour, and some means, he was welcomed and found a seat next to the lady who was enjoying such a run of luck.

Although the stranger appeared a pleasant companion, as they played, the atmosphere of the company began to change. For be it by luck or skill, (afterwards no one was certain) the stranger, quickly relieved not only the boasting lady of her winnings, but played on to gain most of the cash of her companions.

Time passed, as the company played on intently, hoping that their luck would change and eager for a chance to retrieve their money. Hand after hand was dealt, fingers fumbled with tiredness and a card fell to the floor. One of the gentlemen of the party took a candle below the table to retrieve the fallen card, and was startled to see that their mysterious companion had a clubfoot. As he looked up into the man's face, the black clad player disappeared.

For a while there was consternation and confusion, a trick was suspected, some slight of hand. When the party had calmed down, it was pointed out that the stranger's

horse was still locked safely in the stable and that its worth would more than make up for their loss of money. On investigation it was found that the horse too had vanished.

Fear struck the party when It was realised that being so intent on their game, they had, unknowingly, played some hours into the Sabbath. It then did not take the company long to wonder if they had been tricked by a rogue, or the devil himself.

There was a great deal of fear and superstition surrounding playing cards, holding the knave of clubs was viewed as ill luck for instance. Some superstitions call it a death card and in some instances treat it as an omen.

Dickinson tells us that after this incidence some of the company were so affected by a consciousness of evil, that they never played cards again.

It could of course be a 'morality tale', but it is interesting to note that Dickinson states that this story was in general believed.

LOWESWATER

Lying in Loweswater valley on the western side of the Lake District, Loweswater is one of the county's smaller 'lakes'. What Loweswater lacks in size it makes up for in beauty.

There is a good well marked path all the way round this pretty stretch of water, and high on the none road side a former Corpse Road makes a popular walk with superb views. There are, or perhaps it would be accurate to say were, odd remnants of stories concerning this road but they appear to have faded and been forgotten, like so many others, unrecorded.

THE SOLITARY RIDERS

I thank and acknowledge Denise Crellin, colleague and local writer, for some of the information contained in the following tale.

Keeping the lake to your right, on the left hand side of the main road that runs along the northern side of Lowswater, is a steep sharp turn onto a fell road, marked 'Unfit for Motor Vehicles'. The haunting is said to occur at the top of this fell track overlooking Lowswater.

The unfinished road leads to the small hamlet of Mosser, and the mystery. Whether there is more than one lonely ghost? It is not uncommon to have varied versions of the same tale, but this particular group have long persisted as separate stories, although they are so similar they could be suspected of having the same source.

All are well worth telling and are said to date from 1870/80s.

The first is, at first glance, the simplest. A young woman out riding alone, her mount took fright and she was thrown, and she died apparently as a result of this fall. It was some time before anyone realised she was missing, also, some versions say it was days, others weeks, before her frail body was discovered. Her sad ghost haunts the place where she lay dying lonely and unmissed.

The second tale appears to have a little more information. It centres on a strict father, and a desperately lonely only daughter.

Above: Looking across to Mosser from Fangs brow.

Right: The road to Mosser.

The old sign post.

Long after she had given up all hope, much to the surprise and anger of her father, this daughter attracted a suitor. The father's reaction was brutally simple, she must dismiss her suitor or lose her home and inheritance. She chose the suitor.

It is said that she was riding alone, dismissed by her father, deserted by her lover. As to why she was deserted, details are sketchy, but it probably had something to do with her being disinherited. There is also a suggestion that she was pregnant.

In one version we are told that whilst on this lone ride, she was thrown and left dying; lonely, desperate, unloved. In another, it is said that in her despair, using her horse to enable her to reach a high branch she hung herself, and that it was so long before she was found the rope had rotted through and her sad and wasted body had fallen and was almost hidden in leaves.

This girl's body is sometimes seen hanging from a tree, or her ghost observed wandering despairingly in the area where she had laid for so long, unmissed and unmourned.

Yet a third story concerns a vicar's daughter from Whinlatter. This unfortunate woman became pregnant and was then deserted by her lover. She however was supported by her family, especially her father, who declared that her innocence had been abused.

Whilst riding from Whinlatter to visit an aunt who lived in Mosser, this woman disappeared. She was found some days later hanging from a tree, her horse was never seen again. The distraught father declared that his daughter must have been murdered, for he believed her too Christian to have committed suicide.

The shadow of this unfortunate woman has been seen hanging from her tree gallows.

Whether these are three stories, or differing versions of the fate of a single distraught and lonely woman, we will probably never know.

The road beside Lowswater where the nuns have been seen to walk.

MYSTERIOUS NUNS

The apparitions of three nuns carrying what appeared to be a shrouded corpse, was a reported unexplained event that made the national newspapers.

It was in the early 1920s, and four young ex-soldiers were walking along by Lowswater Lake in the moonlight, when they witnessed this sight. In spite of later ridicule, they held to their story and the fact that they were sober.

Frank Carruthers comments that local records attest to an apparently similar apparition being seen by several witnesses some twenty-one years before, which would make it around the turn of the nineteenth/twentieth century.

There is, as far as my present knowledge goes, neither explanation, or any story or legend that might possibly account for these events.

Local folklore does talk of monks and a monastery in Lowswater valley, but thus far no mention of nuns. There is of course always the possibility that the occurrence somehow links to the corpse road.

Intriguingly, there is a similar report of the same kind of apparition, three nuns carrying a bound corpse, the scene of this sighting was St. Helens street in Cockermouth. This is also dated to the 1920s.

KIRKSTONE PASS

What is now the A592 which runs along the northern shore of Ullswater, is part of an old coaching road that crosses the infamous and beautiful Kirkstone pass. This pass links Patterdale and Ullswater to Ambleside and Windermere. Kirkstone pass was, and

at times probably still is, one of the wildest routes in Lakeland, and is also the route of a Roman road. Although now in Cumbria, this area did lay within the boundary of Westmorland.

To join Kirkstone pass from the Keswick Ambleside road, take the steep left hand turn from the roundabout on the outskirts of Amblside, this takes you up the notorious 'Struggle'. This roads snake like twists and turns have been made famous by generations of motor coach drivers, and to attempt it in a horse and trap, let alone a horse drawn coach, must have been truly horrendous.

The struggle joins the main Coach road at a three way junction, Patterdale to the left, Windermere to the right and sitting on the up hill side of this road, fifteen hundred feet above sea level, is the Kirkstone Inn, one of the most famous in Lakeland.

KIRKSTONE INN

Kirkstone Inn is one of the oldest, possibly the oldest, pub in Lakeland. The original foundations of the building are said to date back around 2000 years plus, this building dates to around mid twelve century. It was a coaching inn on one of the main routes between England and Scotland.

Kirkstone Inn sits sombre and mysterious in it's wild and beautiful setting, close by there was a gallows tree, and this is one of the most haunted buildings in the county.

THE MISCHIEVOUS GHOST

One of the phantoms to haunt Kirkstone, appears to be a spirit full of mischief. He was just a lad, a little more than a child when he met his death. It is thought his name was Neville and he was the son of one of the carriage masters.

This cheery little shadow is seen grinning through the windows, sometimes knocking on the glass, and he is thought to be responsible for pranks that manifest themselves inside the building. Moving furniture, stacking it, silently and harmlessly appears to be one of his tricks.

He loved to help his father, jumping up and holding the traces as the coaches came to a halt, assisting in changing horse and harness. It is said he would run forward laughing with excitement as the equipages dashed in, time was always of the essence.

One disastrous day the boy was caught and dragged under the hooves and wheels of a coach pulling in on the way to Scotland. He was much mourned, ever since the lad has haunted the scene of his tragically early death.

RUTH REAY

Ruth was a local girl who lived in the area around the early eighteen hundreds. Within days of the birth of her son she received news telling her that her father was ill. Anxious

that her father should see the infant, she set out to walk over Kirkstone pass taking the baby with her.

Such a journey might appear foolhardy to our modern eyes, but if you had little means walking was the accepted, indeed the only way most of the population had of moving from place to place. Also, they did not have the facility of a reliable weather forcast.

During her journey, Ruth and her child were overtaken by a blizzard. In these our modern times in our protective clothing of fleece and gortex, being caught in a blizzard can be hazardous to say the least. Sadly, in the past, death in such conditions was not uncommon.

Its almost unimaginable to contemplate what this young mother must have endured, struggling on clutching her baby son. Her cloak whipping around her, sodden icy heavy petticoats dragging on her legs, and her boots slithering and soaking as she fought through the snow. All the time thinking of her child, and fighting the numbing, creeping cold. Eventually she was overcome.

Ruth was found near Kirkstone Inn, just a few yards from shelter and safety. Her frozen body was curled protectively around her infant son, who miraculously survived.

Ever since in certain weather conditions the cries of a baby have been heard near the inn, and the dark figure of a distraught girl is seen, she is looking for her child, searching in desperate despair for her baby son.

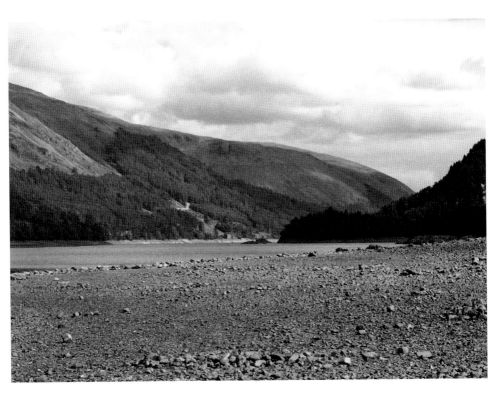

Views of Thirlmere from Armboth Car Park.

ARMBOTH

If you take the A591 from Keswick it is possible to turn onto the road from either end of Thirlmeere, this road (or a well marked footpath) will take you to Armboth car park, which sits on the lakeside below Armboth Fell. The house itself was described as being near Fisher Gill. Now there is nothing of Armboth left, how much was swallowed by the water varies from account to account, but the legends and stories of its ghosts and other phenomenon live on.

ARMBOTH HOUSE

Some commentators call the scene of this persistent story, Armboth House, some Armboth Hall, others including Collingwood in 1902, Armboth Farm. In all of this there is one certainty, the scene of this tale of unfulfilled love and its aftermath now lies somewhere beneath the waters of Thirlmere.

It is an old story and the date has always been a little 'hazy', most commentators agree that it is probably closer to the eighteenth rather than nineteenth century. The legend appears to be centred on Hallowe'en, which, I suppose, could be regarded as a somewhat inauspicious time for a marriage.

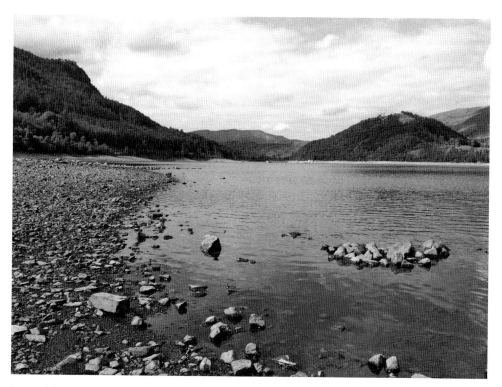

Beneath here the Hall is said to lie, and the black dog swims.

It was Hallows Eve long ago, and Armboth Hall was a scene of celebration and excitement. Wedding preparations for the nuptials of the daughter of the house were in full flow. Garlands were being hung, plate cleaned, tables spread, and as darkness began to fall candles and flares were lit. Every window of the house shone out into the night, declaring celebration.

A distraught man interrupted this happy scene, declaring that the bride was dead, drown. Some versions say that she was betrayed and threw herself into Thirlmere, other versions declare that she was murdered.

Whatever the truth this bride's death appeared to be the trigger for a particular set of hauntings that became well known in the area.

It is said that the house was abandoned, but that ever after, on All Hallows Eve, there were sounds of preparation. Voices were heard and the house shone with light, this phenomenon continued long after the building became a ruin. A wedding feast was being prepared for a ghostly bride who rose from her watery grave to attend.

Also at Hallowe'en a huge dog has been seen to swim the waters of Thirlmere, this animal too is associated with the Armboth bride's death. Collinwood is the only account I have seen to mention this dog's colour, black.

This might seem obvious to some, for the bargest or barguest, (both spellings are used) is black, and, in the north of England, the appearance of this beast is said to be associated with scenes of murder and untimely death. But, the barguest is said to be unable to cross water, so Thirlmeers beast appears to be something special.

Another tale of Armboth that dates from the mid/late nineteenth century, names this sinister house as a Hallowe'en meeting place for wandering and wronged spirits.

I wonder if lights still shine out beneath the waters of Thirlmere on All Hallows Eve.

DALEHEAD

It is said that lights and unearthly fires burst forth suddenly on Dalehead, of, it is often presumed the Dalehead, Hindsgarth, Robinson, ridge. There is no other Dalehead within the Lake District.

I know many people who have been puzzled by this very description. Collingwood writing in 1902 tells of Dalehead opposite Armboth, and mentions mysterious fires springing forth. It would be impossible to see Dalehead from Armboth, and there is no sign of an area called Dalehead on the OS map.

There is, is of course, the simplest of explanations. Most people remember, and are familiar with the story of Armboth. But relatively few remember that there was a Dalehead Hall, on the slopes above Thirlmere, almost directly opposite Armboth.
There was a Boggle at Dalehead Hall, as witnessed by a nineteenth century schoolmaster, one John Richardson. One of the forms, in which this entity chose to manifest was as balls and sparks of fire.

I believe that John Richardson wrote a dialect account of the apparition, in which he mentions not only the Park (of Dalehead Hall) boggle, but also the Armboth boggle, whom he said took on a similar fiery form.

Whether these fires were common to a number of locations perhaps we will never know, but I have been led to believe that these events were once a much talked of phenomenon. These strange fires are said to leave no physical trace, and, like so much else (including the boggle) are almost unheard of in modern times.

It has to be said that the landscaping, (trees) around Thirlmere have changed considerably over the last ninety years or so, and this has made a great deal of difference to the view, also trees have obscured the shoreline and perhaps a great deal else.

Now that the shores have been cleared perhaps more will be seen? But, if we were now to see fires breaking out on a fell side we would probably assume that someone was being careless. The last accepted date of sightings was the mid 1800s.

There are several other sites within Cumbria where fires are said to burst forth of there own accord, and then to disappear leaving no physical trace. 'Morris Guards' is another such example to be found in this book.

These 'balls of fire' are said to be bigger and of a completely different character than, 'will o wisp', 'corpse lights' etc. With the exception of the afore mentioned 'Park' boggle, no traditional stories or explanation, metaphysical or otherwise appear to be connected with these intriguing events.

Marsh gas is given as a possible explanation for some, but several feet in the air, or half way up a mountain?

DUNMAIL RAISE

Dunmail Raise, the pass that takes the A591 from the Western to the Eastern Lake District, from Thirlmere to Grassmere and beyond, has a fascinating history. What is now a well-maintained main road, four lanes across the shoulder, was originally a narrow, easily, and well-defended 'gateway' that once divided Cumberland and Westmorland.

King Dunmail, said to be the last true monarch of Cumberland, fought an infamous battle hereabouts, against, according to legend, Malcolm, King of Scotland and Edmund, King of Saxons. The widely accepted date for this conflict is AD 945. Dunmail was defeated, and his crown, the last crown of Cumberland was supposedly thrown into Grisdale tarn.

Between the dual carriageways at the top of this pass, there is a large cairn, this cairn or 'raise' probably gave its name to the pass, and was said to cover the grave of Dumail himself. Sadly, this somewhat romantic story was apparently and sadly 'debunked' by navies working on the road some years ago. But if you want good luck, join the locals and 'Hail King Dunmail' as you pass in the Grassmere/Thirlmere direction.

In J. A. Brooks, *Ghosts and Legends of the Lake District*, he mentions an old legend that says, Dunmail's crown was enchanted, and that it is the crown itself, that magically bestows Kingship on the wearer. Thus it is vital that it should not fall into undeserving hands.

Brooks also says, that once each year, Dunmail's ghostly warriors ascertain that the crown is still safely hidden within the watery depths of the mountain tarn, then they

raise it up to carry down the fell to the their Kings resting place. Striking the stones of his monument, they call to their chief, Dunmail stirs and his voice echoes out declaring that his time is not yet come.

Each year the crown of Cumberland is returned to its resting place, its warrior bearers, melt into the mists.

NIGHT JOURNEY

There are a number of 'elusive' ghost stories concerning 'the Raise', figures half seen in the mist, crossing the road and disappearing. A percentage, could be, probably are, walkers and climbers. But there are sporadic reports of 'shapeless things', and other comments concerning the way some of the apparently solid figures are dressed.

This story was told to me recently by a family member of those concerned, I record it with thanks.

The date of the first incidence was around the early 1940/50s. Michael (not his real name) regularly brought chassis from Luton, up to Myers and Bowman, a West Cumbrian firm, these trips were usually completed in darkness.

On a number of occasions, when driving over Raise from East to West, Michael distinctly felt a 'presence' in the cab sitting alongside him. This 'thing' had 'nothing of good' about it, and, very distinctly, came and went.

Between what points on the road, or what the timing was, he didn't tell his son, who was my source. But it happened a number of times, and I am told, not on every occasion he crossed Raise.

Intriguingly, another of Michael's sons had the same experience as his father, this happened about ten years ago, he described the presence as evil and when he commanded the presence to go, it went.

Interestingly, this son had the same name as his father.

CROSS FELL

There are a number of hills within Cumbria that, although their present names are probably centuries old, by local tradition, these mountains bear much older names, titles, than those they are known by today.

One famous example is Blencathra, also presently known as Saddle Back, this is the dominant fell if you look east from our wonderful Castle Rigg stone circle. The local, older, name for this fell is 'Hill of The Devils'. Some time ago a friend told me that her mothers name for Blencathra was 'Hill of The Kings'.

Laying north east of Penrith, Cross Fells local name is 'Hill of Fiends'. This could be a clue to the reason for its present name, apparently a cross once stood where the summit cairn is today. The cross was placed there to protect travellers against the screaming entities and spirits long said to haunt the place.

WINDERMERE

Windermere is a lake that has long been frequented by tourists. I will not enter the argument as to which is the busiest or most popular of the English lakes, but Windermere has to be a contender. Lying as it does on the southern side of the county puts this beautiful stretch of water within day trip reach for many of those who live outside The Lake District.

Claife heights lie North of the West side of the ferry crossing, and although it has been much written of in the past, I often wonder if today's tourists look around as they cross and wonder about the Crier.

THE CRIER OF CLAIFE

No book on Cumbria would be half complete without mention of the 'The Crier of Claife', for although it has to be said that not so long ago Windermere was in Westmorland, whatever the official county, the story of the Crier is to my knowledge unique. To date, I personally have never read or heard of anything similar.

In spite of their name it is not Claife heights that are haunted, but the Nab, or so it would appear. What the haunting is, beast, boggle or some other entity is unclear. For it would appear that any and all of those unfortunate enough to have come into direct contact with the Crier of Claife, have either been struck dumb and died shortly afterwards, or have disappeared.

There is perhaps one exception, it has been said that a monk from Furness performed an exorcism in an attempt to lay the entity. It is unclear whether or not he was entirely successful, for it seems he laid the ghost in a quarry, (possibly Claife quarry) some versions say bound beneath a stone, and ever after people refused to go there at night.

The Crier appears to manifest itself first, as a voice. What appears to be a version of the original, certainly one of the oldest and possibly most repeated, stories, tells of a wild and stormy night, and of ferryman on the east shore hearing cries of 'boat, boat,' from the Nab. Reluctantly one of them set out across the storm tossed waters.

He was so long that his friends became concerned for his safety. At last he was seen returning but as he approached the shore, it became obvious that he was alone and that his boat carried no passenger. On landing, the ferryman was found to be incapable of explanation, he had been struck dumb, and appeared terrified. The man died a few days later, still unable to speak or to indicate anything of his experience.

For some time afterwards, on stormy nights the cries of 'boat, boat,' were heard from the direction of the Nab, not surprisingly the ferrymen refused to go, although some of the cries could have been from genuine passengers. It was said that eventually no ferryman would cross the lake after dark, storm or calm.

Still the cries continued, until eventually the exorcism was performed.

This is a difficult story to date, there have been stories of cries and screams, some sources say, into the twentieth century, it was apparently much spoken of well into the nineteenth.

There have been suggestions that the loss of a wedding party contributed to the original haunting. Collingwood mentions that a ferry carrying some forty-seven people was lost with all passengers at this crossing in 1635, and that a wedding party were among those drowned.

The Furness monk who performed the exorcism is believed to have been living in a Chantry Chapel on an island in Windermere, if true, this could put the date back to fifteenth/sixteenth century.

A fascinating and unusual story, I am rather glad that the Windermere ferry no longer consists of a ferryman and a rowing boat.

BARROW HOUSE

Barrow House in Borrowdale valley, just a few miles from Keswick, is another Youth Hostel with a reputation for being haunted.

A stunning 200-year old mansion sitting on the shores of Derwentwater, it boasts fine grounds and stunning views. I remember being there in the sixties and seeing long lines of 'service bells' in a downstairs corridor. Although these bells had been long disconnected, wires cut, they were said to move and ring of their own accord.

An ex-warden, now retired, has had a number of sightings of an old lady. She was seen only at night, close to the then, bathrooms.

The present wardens have been at Barrow house for twenty years, and although aware that the house has a reputation for being haunted, have not had, or been aware of any unusual experience there.

But the service bells are no longer there, so perhaps there was a reason for their removal?

OVERWATER HALL

Follow the A591 from Keswick to the cross roads beside Castle Inn, take the right hand road to Uldale and Ireby, and continue until you see an estate road clearly signposted to Overwater hall on your right.

Overwater Hall is a lovely Georgian house, now named for the stretch of water nearby. For some years Overwater has been a hotel, and is the setting of an intriguing ghost story.

I was fortunate in having the opportunity of talking to a number of people, who have, and have had, connections with Overwater, past and present.

THE JOHN PEEL STONE

I was shown the John Peel Stone by Mrs. Hind, a charming lady whose father Mr Alfred Gatty was a past owner of Overwater Hall and lands. Mrs. Hind owns a house and land on the estate, where she still lives. When her father bought the Overwater estate in 1929 the house was called Whitefield, its name change was due to the possibility of confusion with another house of similar name in the local area.

Born, and living here until her marriage, the accepted story behind Overwater's ghost was well known to Mrs. Hind. She told me quite clearly, that although she had played in and ran the house and grounds at all times, dark and light, both she and her siblings had never seen or heard any sign of Overwater's lady. She went on to comment that their dogs had always remained undisturbed.

She also spoke to me of Joseph Gillbanks, a previous owner of Overwater who features in the story that had engendered the ghost. Mr. Gillbanks who owned Overwater (then Whitefeild) in the early to mid 1800s, was a friend of John Peel, and raised what can only be termed as a 'folly' to this infamous huntsman.

I was taken to see this, surrounded by dogs we had a wonderful walk with the cloud over Skidaw chuttering and threatening in the background. The John Peel Stone is a high sandstone plinth, surmounted by a carving of John Peel complete with top hat.

On our way back we circumnavigated Overwater Hall, while Mrs. Hind pointed out things of interest, including the nursery occupied by herself and her siblings, this

Right: The haunted tower.

Below: Overwater Hall.

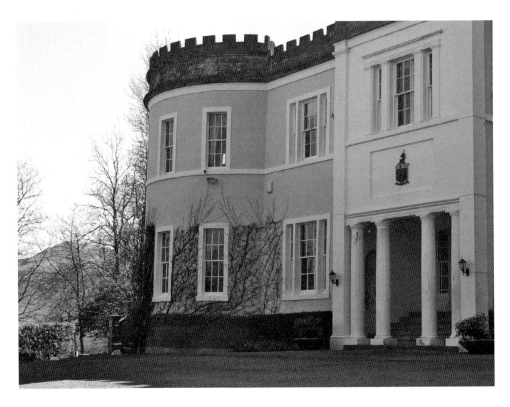

Above: Overwater

Left: The John Peel Stone.

room occupied the tower at the opposite end of the house (front right) to that said to be haunted. Local belief and opinion appears to be that, haunting aside, a lady conveniently disappeared.

OVERWATER'S GHOST

The broadly accepted story behind the haunting of Overwater Hall, is one of deserted love. A previous owner of the house and estate went, or was sent, to Jamaica at the age of twenty to make his fortune. Whether he went by choice or at the behest of his family, is not known, it was not uncommon for a son to be 'sent' to the West Indies in hope of topping up the family coffers.

The man at the heart of this tale is usually thought to be Joseph Gillbanks, basically, because the dates fit. He returned from Jamaica in 1814, and bought the Overwater estate, on his building or altering the house, opinion is divided but he was clearly a man of some wealth.

It is said that a woman followed him from Jamaica, whether mistress or wife is unclear, but she regarded herself as wronged and deserted. According to the accepted story, he persuaded his former love to join him in a rowing boat on Overwater Tarn, a short distance from the house, to discuss the situation.

During the course of this meeting he threw her from the boat in an attempt to drown her, she clung to the side in desperation, so, taking his sword, he hacked off her hands.

It is said that the ghost of this betrayed and deserted woman, bangs on the windows of Overwater Hall, with bloody handless arms, begging to be admitted.

In the past her ghost has often been described as 'exotic' in appearance, but it is unclear whether this refers to dress, skin colour, or both.

One of the first written versions of this story, I believe, appeared in the press around the late 1800s, and it has been widely recorded since.

THE HAUNTING OF OVERWATER

I visited Overwater Hall in April of this year (2010) and spoke to Stephen Bore, who was immensely helpful. Among other information he had a file of good concise research regarding the house, its history and background.

Stephen also had some fascinating and surprising information in respect of Overwaters ghost. She, the ghost, is female, and is seen regularly by guests, usually women. She is seen indoors, not knocking on the window in despair. There is a report from the 1800s, when a servant reported seeing a female figure walking through the front door, up the staircase and entering the 'best' bedroom, passing straight through closed doors on her way.

It is now a little unclear which would have been regarded as the 'best' bedroom at that particular period. A female entity is seen in room 3, which occupies part of the left hand tower as you face the house. For practical reasons this tower is now split into two

bedrooms, 3 and 4, both are beautiful with wonderful views and I could well believe that this tower in its original configuration would easily fit the description of the 'best' bedroom.

Regularly seen by guests who comment, apparently unprompted, on one particular item of her dress, the ghost of Overwater is reported to appear through the left hand wall of room 3, and to disappear through the wall leading to room 4.

In spite of rooms 3 and 4 previously being one larger room, there has never been a reported sighting or experience from room 4, until recently.

A couple of days before my visit to Overwater, a guest had reported a sighting and was willing to talk of her experience, which turned out not to be her first. I am fascinated and grateful for her first hand written account, and her permission to publish it, verbatim.

EXPERIENCE

I have been to Overwater four times now although my partner Guy has been more often. First visit was September 2000. Subsequent visits were Februrary 2009, and April 19th-21st 2010.

Each time we have gone there we have been allocated room 3 (interesting) I first felt and saw a presence in February 2009 when I saw a female in the room. She appeared from the left hand side of the bed from the wall behind the writing desk, walked around the bed slowly and disappeared out of the right hand side wall. Her appearance was not detailed but she appeared dark (but not in flesh), she had either long hair or something over her head and her cloths were not fitted or luxurious, with no detail of note. I did not feel at all fearful of her and she didn't seem to have any interest in me.

During our visit in February 2010 we took with us our dog who stayed in the room, I did not encounter any experience at that time. But on reflection the dog wanted to stay by the door which we put down to the warmth of the room at the time, but who knows?

Our visit to Overwater on April 19th was to celebrate my mothers birthday, so we took with us, both Mum and Dad who stayed in room 4. During the night of 19th/20th I was awoken by what can only be described as the bed and covers being shaken insistently. This went on for what seemed a considerable time but was probably less than a minute. I sat up in bed, Guy was sound asleep and was not moving, The covers remained in place. It was a pretty frightening experience and I was reluctant to go back to sleep. The room was very cold which is unusual for Overwater Hall as their heating is very efficient. Tiredness got the better of me and I fell back to sleep. (I did not check the time)

Some time later that night the experience happened again, this time with more urgency and intensity. It felt as if I was immobile in the bed with a heaviness on my chest as if my lungs were squashed. The shuddering continued longer this time. I was fully aware of where I was and the room around me. I did not see any presence but the concentration of energy in the room was vast. It was as if I had to break free of

the energy to stabilise the situation. It was at this point that I realised that the plane where you are aware of these entities, is just next to full focus of normal reality, which is somewhere between reality as we know it and dreaming. You are fully aware of your environment and have some consciousness but your focus is not as engaged as it is in daily life. When I was able to refocus, I checked for Guy's reactions; he was still asleep! This time I was really spooked! My choices were to sit up all night in the chair as I was too frightened to go back to sleep and get the room changed the next day, or see what this presence wanted. It was clear that it wanted my attention, which it had!

When I calmed myself and settled back down in bed (which seemed the safer, less vulnerable of the options), I decided with what seemed to be a 'her'. I asked her what she wanted and the response was "pretty ring" (I had left my ring on the writing desk by mistake instead of wearing it during dinner and had put it back on when I went to bed.) She repeated "pretty ring" several times. I asked her again why she wanted to engage with me and again I felt a disturbed energy. Not enough to move the bedclothes this time. I guessed that something had disturbed her and asked if she knew what it was. It was at this point I had a sense of WiFi, but I don't know where it came from. There was a feeling that the energy around her had changed and that she was uncomfortable in it. I asked her if she wanted to move on to the next level. There was a great feeling of fear around that question. So I asked her what she was afraid of. I could sense that the fear was about family and that they may be on the other side waiting for her. Using my small amount of knowledge of families of consciousness from where we come from before physical reality; I assured her that there was nothing to fear on the other side and that the loving energy, that we are all connected to and are a part of, even while we are here in physical reality, would welcome her back. There was a sense of warm loving energy encouraging her back. Then all was peaceful in the room.

This presence was not threatening or terrifying but her energy was disturbed, but it was just the engagement with her was alarming me.

I was exhausted and got up to go to the bathroom and have a drink of water, I checked the time it was 3.25 am. Guy awoke and asked what the problem was. All I could say at that point was that I was a little spooked. I could not give any more detail the words wouldn't come.

On the morning, I told him of the full experience and although he had not experienced anything specific, he had felt a swirling energy in the room, which he too had sent peaceful thoughts to.

At breakfast, the usual "Did you sleep well?" conversation was exchanged and my mother said she had experienced strange things during the night. We pressed her for detail and without any prompting described exactly the same disturbances on the bed and bedclothes. She said it felt as if someone was jumping on the bed, pulling the bedclothes. She thought that my dad was having a very rough night! But he slept soundly. The experience really frightened her as she is not one to have psychic experiences. It seems that mum was witness to both experiences that were happening simultaneously or consecutively. She thought it was about 3.15 when the second experience happened.

My background is:

I am a Reiki master teacher and work primarily with horses and other animals, working with either 'hands on' sessions or distance work. I am not usually Visio-sensual and when working with animals and humans have more of an ability to feel an issue rather than see it.

I have also spent many years working with spiritual self development, studying many alternative views into personal reality in this life and why we are here. This incorporates redefining how we live our lives and adding a new perspective of aligning ourselves with a more complete self.

So I guess I was just an easier person to communicate with!!　　GILL.

ST. JOHNS IN THE VALE

Just to the South of Keswick, the road through this lovely valley joins the A66 at Threlkeld, to the A591 that takes you over Raise, the turning from either A road is well sign posted in both directions. The beautiful 'Vale of St. Johns' is ever associated with the Knights of St. John of Jerusalem, Knight Hospitallers, who for a time made this valley their home.

Entering the vale from the A591 takes you past the wonderful Castle Rock of Triermain, so romanticised by the Victorians. Its own history and legends are enough – it needs nothing added. Its stories include it being the home of sleeping knights, capable of being awakened by a magical formula, association with King Arthur, and the ability to turn into a real castle.

There is evidence of fortification on the summit of the rock, possibly the type of fortification, which would, in its own time, have been regarded as the equivalent of a castle or fortress. The rock is an excellent defensive position.

LOW BRIDGE END FARM

Low Bridge End Farm's house and buildings sit on the side of the vale, below High Rigg, and although just a few metres away, from the farm, the road is invisible. The setting is wonderful, and the house has an energy described by Mrs Chaplin Bryce, who lives there with her husband and sons, as magical. Although I was there only briefly, I have to say that I share her opinion. There is something about this place.

Mrs. Chaplin Bryce went on to tell me that she is aware of and accepting of her lovely home, and its ghosts. Shadows and figures are seen regularly, but not in regard to certain, specific, times or seasons. With one exception, any disturbance in the adjacent camping barn usually occurs about 3pm in the morning.

Low Bridge End is a working farm, and there is also a camping barn that is in regular use and a teashop that is a mecca for passing walkers and others. Visitors have on occasion, themselves, been witness to some of the phenomena.

Camping barn.

Visitors often witness phenomena.

Figures have been seen walking across this yard.

The farm from across the river.

On the upper floor of the barn I have personally been told of one visitor, who was sleeping by the back wall, being pushed off her mattress as though by a door opening and someone walking through. Needless to say, there is at this present time no physical door in the wall in question. I have heard since, of other similar occurrences.

Also within the barn, there was an incidence during a guided meditation. Everyone was in a circle, with candles set before them, the teachers eyes were open. I am told that all the candles went out, the teacher's candle re-lit, the flame bent diagonally, then straightened itself and burned high, bright and steady for the rest of the practice.

The energy in the room was later described as 'interesting'.

There was one incident related when a visitor was truly 'spooked'. There is a fine wooden staircase in the barn, just to the left of the door as you enter, a man, described as wearing a long coat and a pointed hat, appeared at the foot of the staircase in question, stuck out his tongue at the shocked lady, then disappeared.

It is tempting to think of the 'pointed' hat, as a wizard's hat, but, our Norse forebears used to wear a kind of small pointed hat of a kind of 'felted' rough wool, a style that probably carried on through many generations.

Some other visitor experiences; a group of army cadets were disturbed, and spent part of one night looking for the source of music that was keeping them awake. This music is part of the phenomena of the area. A night or so later the same cadets were out of their tents looking for a crying baby that seemed to be in some distress.

In regard to the house itself, Mrs. Chaplin Bryce related a number of fascinating incidences that she had personally witnessed. She also spoke of the energy within the house being 'different' when her elder son was a baby, then over the years it had become more 'settled'. It was also while this older son was small that she witnessed the only poltergeist activity that she had been aware of in the house. Things being moved, and plates tipping out of cupboards, but she had felt it to be more mischief, than harmful.

The energy in the house had actually felt better, she said, since, during alterations, a new doorway had been knocked through a wall in the main living room. There was a particularly curious incident within this room: Mrs. Chaplin Bryce had settled her baby son upstairs, like many old houses the stairs have a door at the bottom which leads straight into the main living area, as she opened this door she became aware of a baby laying in a wonderfully carved cradle, between the inglenook and the window. This child was being watched over by a young man and woman who stood before it. The scene faded, and thus far has not been seen again.

This central part of the house appears to be the scene of most activity, and with the exception of the woman that stood over the cradle, the ghosts and shadows appear to be male. The door to the staircase is in the back wall and faces the front door, which is in a corner, to the right of this door there are windows. The inglenook sits in the right hand cross wall, and the door to the kitchen goes through the back corner of the same wall. The 'new' doorway is in the cross wall between the stair and front doors, and faces the inglenook.

Two of Mr and Mrs Chaplin Bryce's sons, have seen figures in this room. The elder told me that the man he saw, came from the stairs and crossed to the front door. The figure had been dressed in quite ordinary jacket and trousers. Just a day or two before I visited the farm, the younger son had been sitting facing the television set, which stands in the corner where the cradle was seen. The set was off, when he saw a shadow reflected in the TV screen. This shadow passed behind him in line with the front door and stairs.

It is absolutely certain that there was no power in the television at the time, for, since digitalisation no reception is possible.

An old man is seen crossing the yard in front of the farmhouse, heading towards the front door. Also, Mr Chaplin Bryce mentioned the possibility of a corpse road crossing the yard, and he told me that the vale is a rift valley, and they do get earthquakes.

Low Bridge End Farm is a fascinating, beautiful and intriguing place. My sincere thanks are due to the family, firstly for their time, and also for allowing me to record their experiences.

LANGDALE

Langdale is a valley of the eastern Lake District, the A593 will take you from Ambleside to Skelwith Bridge from there, follow B5343 to greater Langdale.

Dominated by Pike o' Stickle, Harrison Stickle and Pavey Ark, collectively known as the Langdale Pikes, this superb valley is one of crags, screes and boulder. There is a famous Stone age 'axe factory' on Pike o' stickle, examples of its output have, I believe, been found in Europe. This says something for the trading routes and skills of our ancestors.

THE POWDER FACTORY GHOST

The tragic victim of an explosion, which occurred over ninety years ago, still appears to haunt the site of his death. The former site of the powder factory at Elterwater in Langdale, has, over the years, been a caravan site, the Langdale Outdoor Education centre, and more recently, a time share complex.

There have been few recent reports of the ghost, described as a man in 'old fashioned' clothes, the most noticed items consisting of a leather cap and collarless shirt, but there has been recorded sightings for over thirty years.

The gunpowder factory on the Langdale Estate closed down in the 1920s. The accident, which appears to have engendered the haunting, occurred in September 1916. A contemporary report was published in the *Westmorland Gazette*, where a photograph of John Foxcroft, one of the four victims of the tragedy, bears an uncanny resemblance to descriptions of the ghost. This likeness came to light, when two schoolgirls who had been staying at the centre in the seventies, were asked to make drawings, after encountering the spectre.

There appear to have been numbers of sightings of the apparition, at the outdoor centre. The bearded figure was seen in the canteen and dormitories, and there have been reports of him looking through windows, and wandering through the trees.

A report from the nineties, describe him as 'appearing from nowhere' and gliding by.

Later reports describe him as being seen, from the knees up. Interestingly, some of the earlier reports, describe his boots.

THE BLAST MONSTER

An entity that has become known as, 'the blast monster', is regularly heard outside two chalets on the Langdale Estate. Chalets close to an old 'blast wall' (a protective wall built for shelter when blasting was in progress) the sounds of footsteps on shillies are heard in the darkness.

I have been told that visitors to this part of the estate now take this entity's visitations almost as a matter of course.

CONISTON

The A593 from Ambleside will take you to Coniston. Diana Whaley's excellent *Dictionary of Lake District Names*, tells us that in some older Books, Coniston Lake was named Thurston Water, and also, that Coniston means, 'the king's estate or mere'.

There is certainly mineral wealth in this valley, wealth that our ancestors fully appreciated and made use of. It is easy to imagine how attractive such a place would have been, to an ancient monarch.

The Coniston area has been a mecca for climbers, from the early 'tigers' to the present day, and has some of the finest rock climbs in the Lake District.

CONISTON OLD MAN

A wonderful mountain, in spite of being mined and quarried by generations of men, who sought its riches, the Old Man keeps its dignity despite the scars. A source of copper and slate, Harry Griffin, in his 'Roof of England', talks of garnets in the spoil heaps. Then goes on to comment on the possibility of remnants of a civilisation, 'thousands' of years past, and the stone circle south of the Walna Scar track. This is 'Banniside', not one of the best known, there is an excellent description and plan in 'The Stone Circles of Cumbria' by John Waterhouse.

Somehow this is an area where you would expect to find a circle, for this is a mountain that many people find 'mysterious', there are many old, almost indeterminate, stories woven around Coniston Old Man and the surrounding area.

Old lore, speaks of fairies and other less likeable creatures, under and around the slopes. Such things were, in ancient times, often associated with quarrying and mining, always, and still a dangerous occupation. In the past especially prone to superstitions, 'resting' minerals from nature- mother earth.

I know of no recent sighting of any kind, on or near the mountain, but in 1954, photographs of a flying saucer seen there made the tabloids.

There are still many who believe that Coniston Old Man, has a very special energy.

SIMON'S NICK

Our Norse ancestors believed that mountain summits were the homes of the gods, and within the length and breadth of Lakeland, there are many stories of voices and unexplained figures in the mist.

In the past when there were fewer people on the hills and crags. I suppose that the sound of voices seaming to drift from a nearby rock face, that subsequently proved to be deserted, or figures on a ridge, that disappeared, were more noticeable

Seeing the broken rocks and abandoned workings around Swirl How and Coniston Old man, it is easy to see how the stories of abandoned city's and the like arose with our forebears.

Swirl How is a mountain where you could easily imagine strange happenings. Close by Coniston Old Man, Swirl How is also a mountain of shafts, caves and potholes. Harry Griffin and J. A. Brooks, among others, mention a huge rock cleft, called, Simon's Nick, that is reputed to be haunted.

The story goes, that an old miner named Simon found a rich vein of copper in this cleft. Refusing to tell other miners the location of this lode, he boasted that he had been led to riches by fairies.

However, ill luck seemed to follow him, there were a number of accidents, and his stores of ore were stolen, time after time. Then one day he miscalculated, and was blown up by his own gunpowder. Sadly, the way this old miner met his death was not uncommon.

It is said that Simon's ghost appears, grinning widely, hanging from the crag that bears his name.

I wonder how many climbers have heard of, or even seen, Simon?

TARNS

There is something in excess of a hundred tarns in the lake district, ranging in size from virtual puddles to a small lake. Some cause great argument, as to whether or not they should be classed as tarns.

Many tarns are said to be bottomless, or to contain great treasure. Mockerkin Tarn, close to the A5806, is said to have the remnants of a palace beneath the mud, and a giant pike.

Others have been said to contain, in various combinations, giant fish (of various types), hairy trout, blind trout, trout with enormous teeth and 'wise' fish that are millennia old.

But there are some others tarns that are somewhat more sinister.

West of Dunmail, Codale Tarn is said to reflect the faces of the dead, while Easdale Tarn is said to be the home of a lost soul.